ARTas1

Japanese Professional Illustrators - Vol. 2

ART as 1®

ART as 1® Japanese Professional Illustrators - Vol. 2

Toshihiko Takabatake
President / Publisher

Paul Archuleta Whitney
Vice President / U.S. Sales & Licensing Director

Chitaka Obara
Art Director / Book Design

Minako Takizawa
Editor / Translation

Thomas R. Hummel
Copy Editor

**U.S. Art Sales & Licensing
Authorized Representatives:**
Eric S. Cygiel
Andrew L. Spitzer
Jeffrey Zahn
Teri Duerr
Sharon Hamilton
Stanley Lozowski

Japan:
Hiro Shibata
Executive Director / Creative Director

Misae Ohtsuki
Coordinator

Toppan Printing Co., Ltd., Tokyo
Printer

Printed in Japan
ISBN-13: 978-0-9776143-1-8
ISBN-10: 0-9776143-1-X

ARTas1®

Japanese Professional Illustrators - Vol. 2
(A Collection of 27 Top Contemporary Japanese Visual Artists)

Welcome to *ARTas1*®, a project that brings the Japanese and worldwide art communities closer together as one, while exalting each unique artistic creation as the only one of its kind in the world.

It is our privilege to introduce artwork to you from 27 of Japan's top contemporary Japanese visual artists in this *ARTas1*® - Volume 2 compilation. *ARTas1*® is proud to be the stage from which many Japanese artists are now launching their international careers. In our previous issue, *ARTas1*® - Volume 1, our members met with substantial success, including participation in international competitions, licensing of existing images to products such as greeting cards, commissions for customized figures from concept to completion, customized characters, design of video game characters, illustration of children's stories, book cover designs, advertising campaigns and so much more.

We thank the international art community for your support.

We believe you will be very pleased with our *ARTas1*® - Volume 2 members, including several never-before-seen "newcomers" we have the privilege of introducing to the world market. These artists were selected as some of the very best in Japan's vast pool of talent. They have achieved success in one of the most competitive art markets in the world. And they all are eager to expand onto the international art scene. This puts you in the unique position of having some of the first options and contracts with these great artists.

We invite you to contact the artists directly using the e-mail addresses listed on their pages or to contact us, as we are their Authorized Art Licensing Agency. Even if you just have simple questions, would like to discuss their techniques, or ask questions about mediums used, sizes, etc., please don't hesitate to ask. Great things can happen when we bring these art worlds together. We look forward to hearing from you.

The following comments came from customers who used our services, hired our artists, and garnered lasting impressions of what it's like to work with *ARTas1*®.

Upon receipt of artwork for a "build to order" 3D CG character which was delivered ahead of schedule, one client commented:
"WOW! This is amazing. AMAZING! I can't believe how cool this is. I have worked with a lot of illustrators, but this is the first time that I was shocked to see how great something turned out to be."
 — Matthew Goodman, Perseus Books Group

Upon receipt of an illustrated children's story, again delivered ahead of schedule, another client sent the following praise:
"The *ARTas1*® artist's illustrations went the very smoothest of all... Couldn't have been better."
 — Jodie Hein, Silver Editions

Every client we have worked with has had a positive and satisfying experience with *ARTas1*®. We hope you will contact us and give us the opportunity to exceed your expectations on your next project as well.

Toshihiko Takabatake
Publisher
Japan Publicity, Inc. / ARTas1®

PEACEMEBIUS

ART as 1®

Contents

Human beings have always been visual communicators, progressing from pictographs to letters and from letters back to pictures. Illustration continues to develop as an attractive, charming, and poignant method of expression throughout all types of media as "illustration art." However, the fact that illustrations can be understood at a glance makes them capable of filling in the blind spot for all languages. Illustration can get in to people's hearts instantaneously and naturally, leaving a deep impression that includes emotions that cannot be put into words; that is part of what makes it such an aesthetically pleasing form of communication. Humankind's thoughts and ideas have been carved into history through countless words and images. These "visual messages" still appeal to us today, transcending space and time. Sometimes easy to miss, the significant role that illustration has played throughout history and all its accomplishments must be recognized. Surely, without illustration, human communication would have been empty and lonely. Illustration is an important "man-made" technology, and a vital part of our human culture.

AWARDS: Warsaw International Poster Biennial Gold Prize; Bruno International Graphic Design Biennial Artia Prize; Africa Protection of Natural Environment Tunisia Embassy Prize; Mexico International Biennial of the Poster Honorary Mention Award; Helsinki International Poster Biennial Honorable Mention; New York Festival Design & Print Silver & Bronze 1995 and 1997-2001 Finalist Award, ("No More Nuclear Testing By India" 1998); United Nations DPI Award; The Art Directors Club 72nd Annual Awards 7th International Exhibition Distinctive Merit Award (AIDS Campaign Poster); and many more...

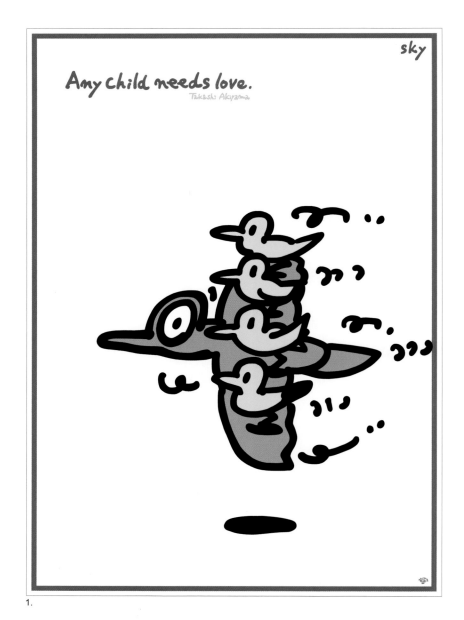

1.

Takashi
Akiyama

Takashi Akiyama B.A., Tama Art University, Tokyo / M.A., Tokyo National University of Fine Arts and Music / Currently Professor of Art, Tama Art University
E-mail: takashi_akiyama@ARTas1.com **URL:** www.ARTas1.com/info/takashi_akiyama
Tools: "It's my secret." **Titles:** 1. Any child needs love - sky 2. Any child needs love - forest
3. Think the Earth - Water 4. Think the Earth - Knowledge All images pages 6-9 © 2008 by Takashi Akiyama

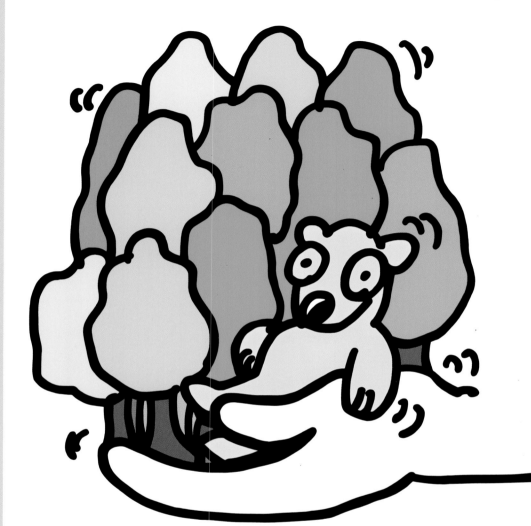

Any child needs love.
Takashi Akiyama

2.

THINK THE EARTH
water

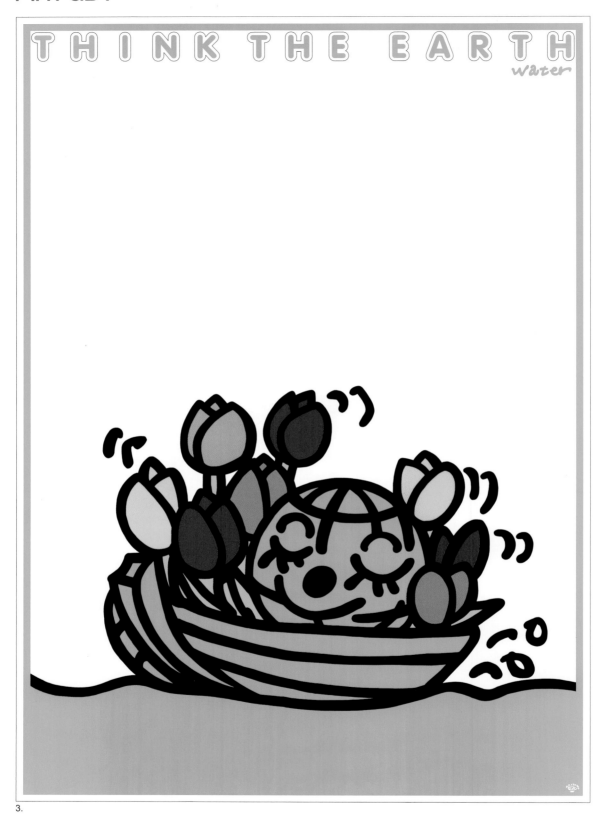

3.

4.

ARTas1

"My characters have a universal appeal and an intriguing power that energizes the audience's spirits," says Ms. Miyao. While running her design firm in Tokyo, she has created many characters for major corporations over the decades and is acclaimed as one of the leading artists in Japan. Her new character-based work, *The Sushis!*™, was created with animation in mind. Each Sushi character has a bold presence and "personality" to attract the attention of a wide audience, especially young children and adolescents.

CLIENTS: Hitachi, Japan Broadcasting Corporation (NHK), Fuji Television Network, Nippon Television Network, Kodansha, Shogakukan, Benesse, Gakken, Fusosha, House Shokuhin, Meiji Seika Kaisha, Bourbon, Mister Donut, Oji Paper Group, The Japan Crown, Takeda Pharmaceutical, Taisho Pharmaceutical, and many more...

©Reichel Miyao

1.

Reichel **Miyao**

Reichel Miyao Design B.A., Tama Art University, Tokyo
E-mail: reichel_miyao@ARTas1.com URL: www.ARTas1.com/info/reichel_miyao
Tools: Adobe Illustrator CS, Adobe Photoshop CS2, color pencil, marker pen Titles: 1. The Sushis!™
2. The Sushis!™ 3. B. B. Bear 4. B. B. Bear All images pages 10-13 © 2008 by Reichel Miyao

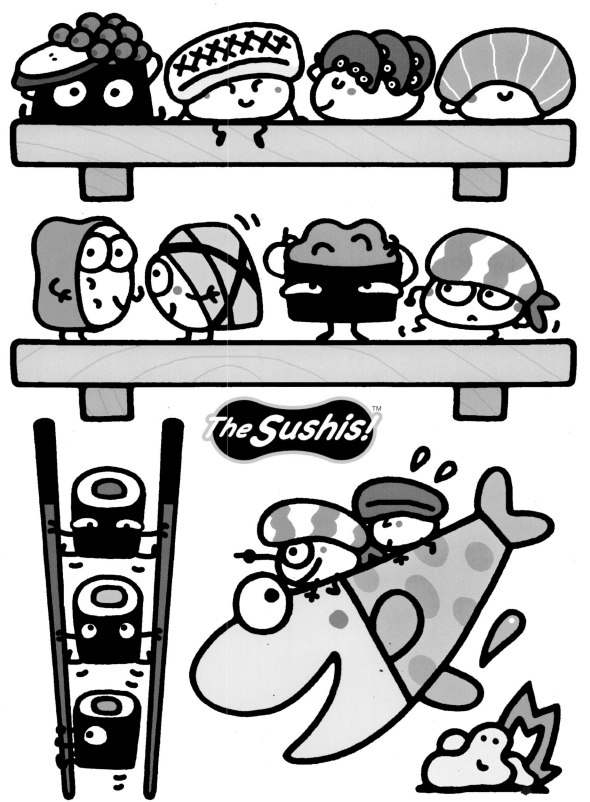

The Sushis!™

ARTas1®

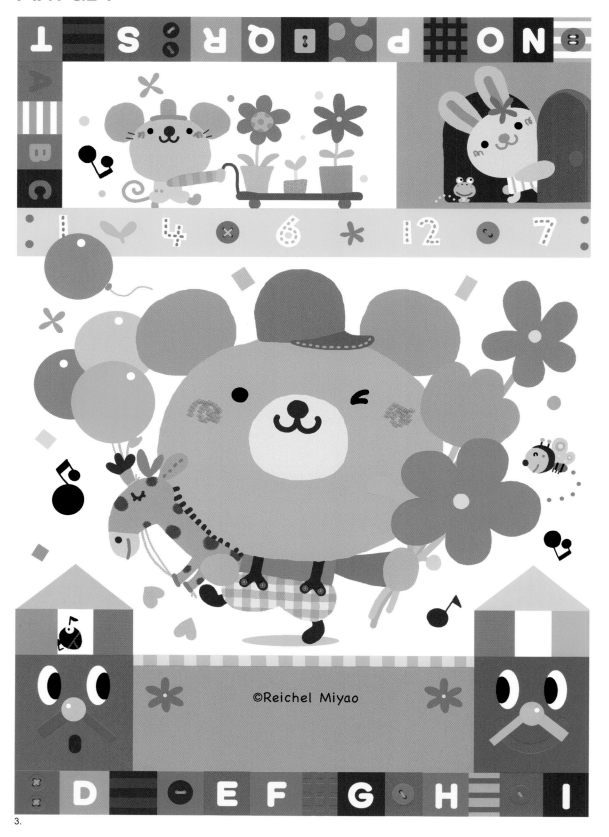

©Reichel Miyao

3.

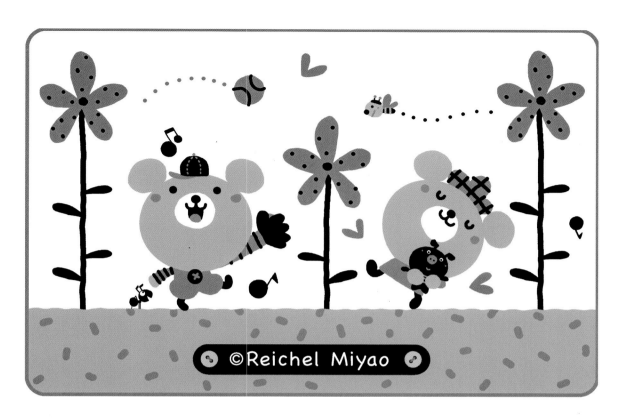

©Reichel Miyao

B.B.bear

4.

ARTas1

Mr. Yoshii is one of the most acclaimed digital artists in Japan. He freelances as an illustrator and has created various characters for major TV programs, commercials, corporate websites, campaigns and events. Yoshii specializes in crystalizing characters for his clients' needs with little direction. "My three-dimensional characters are created by a harmonious combination of beauty, ludicrousness, and humor." In 2006, Yoshii began the tedious process of hand-making vinyl figures. Specialty shops in Japan sell out of his limited edition figures quicker than he can make them. He also supplied 10 figures to Pixologic, Inc. for use as corporate/promotional gifts. Yoshii is currently creating a series of figures for larger scale production.

CLIENTS: Character design and development, visual promotion and animation: Perseus Books, area/code inc., Maxell, Gloria Jean's Coffee (U.S.A.), Kodak Japan, Total (France), Matsushita Electric Works, Japan Telecom, TV Tokyo, Nippon Television Network, House Foods, Mac Fan Expo, E3/Tokyo 1996, and many more... Covers: Reading [SCHOLASTIC USA], French monthly magazine SVM Mac, Quarterly CD-Rom Nikkei Corporate Information (Nihon Keizai Shimbun), WWW Yellow Pages [AI Publishing], illustrations for the column pages of French weekly magazine Le Point, and many more... Web Animation: OLYMPUS

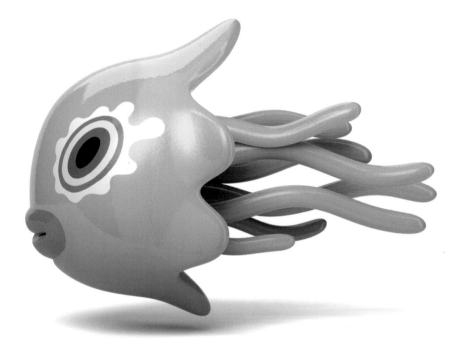

1.

Hiroshi **Yoshii**

Hiroshi Yoshii
E-mail: hiroshi_yoshii@ARTas1.com URL: www.ARTas1.com/info/hiroshi_yoshii
Tools: computer Titles: 1. Jelly 2. Oraora 3. Bugccho 4. Orange Man 5. Daiko 6. Ho 7. Naam

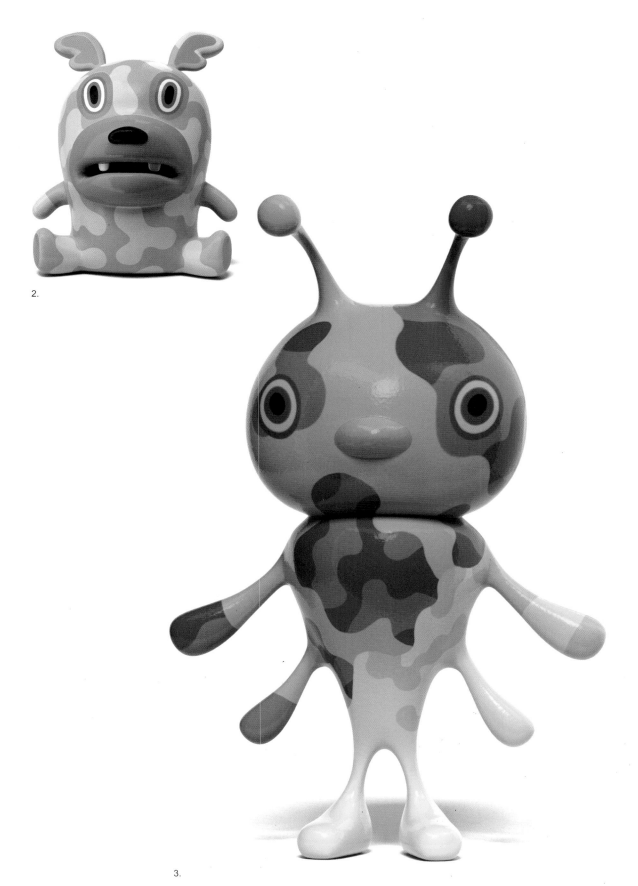

2.

3.

4.

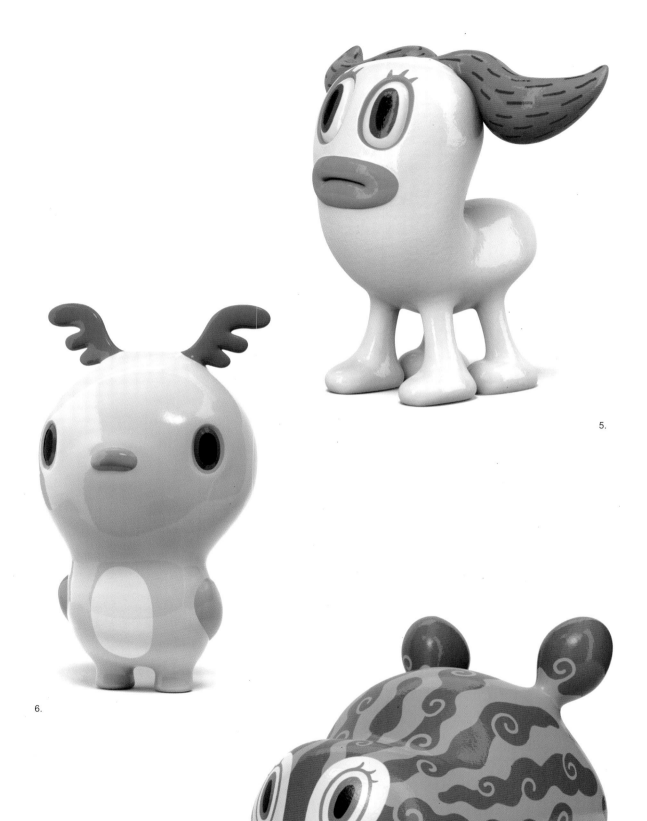

5.

6.

7.

![ARTas1]

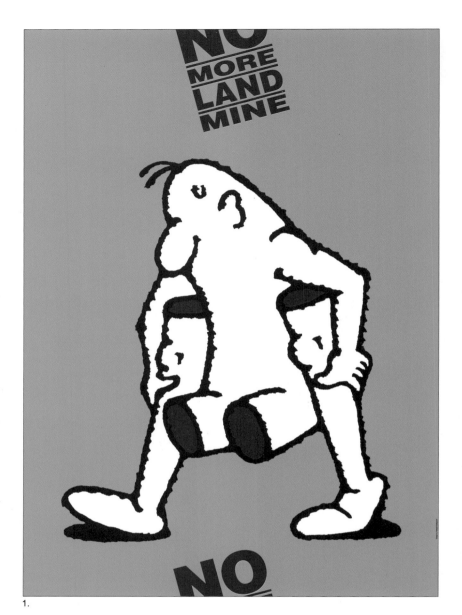

1.

Mr. Sekiguchi has been an outstanding member of the "MANGART" group, whose aim is to fuse the aesthetic and conceptual approach of manga (comics) and art into one genre, since 1986. His subject matter exposes the darker facets of humanity, such as crime and violence, with a sharp but incisive wit. Member of The Japan Cartoonists Association and Japan Graphic Designers Association (JAGDA).

CLIENTS: Publications: Wild Bird Society of Japan award-winning book *Miru Yachö-ki* (watching wild birds) Vol. 1 - Vol. 20; Art Box Takashi Sekiguchi Manga Collection *Freeze!*; Asahi Shimbun serialized column "My Point of View – Weekend"; and more...

AWARDS & SHOWS: International Poster Biennale in Mexico 3rd Place Prize; 11th Chaumont Poster Festival in France 3rd Place Prize; 5th Humorous Advertisement Contest Top Excellence Prize; The Art Directors Club Annual Awards ('92, '93 and '94) Merit Awards Tehran International Cartoon Biennial; and many more... Exhibitions at Warsaw National Caricature Museum, Contemporary Japanese Cartoon Exhibition and more...

Takashi
Sekiguchi

Takashi Sekiguchi B.A., Tama Art University, Tokyo
E-mail: takashi_sekiguchi@ARTas1.com **URL:** www.ARTas1.com/info/takashi_sekiguchi
Tools: pencil, Ink, watercolor, Adobe Illustrator, Adobe Photoshop, my brain **Titles:** 1. landmine
2. terrorist (P19) 3. manners 4. chef 5. guillotine (P21) All images pages 18-21 © 2008 by Takashi Sekiguchi

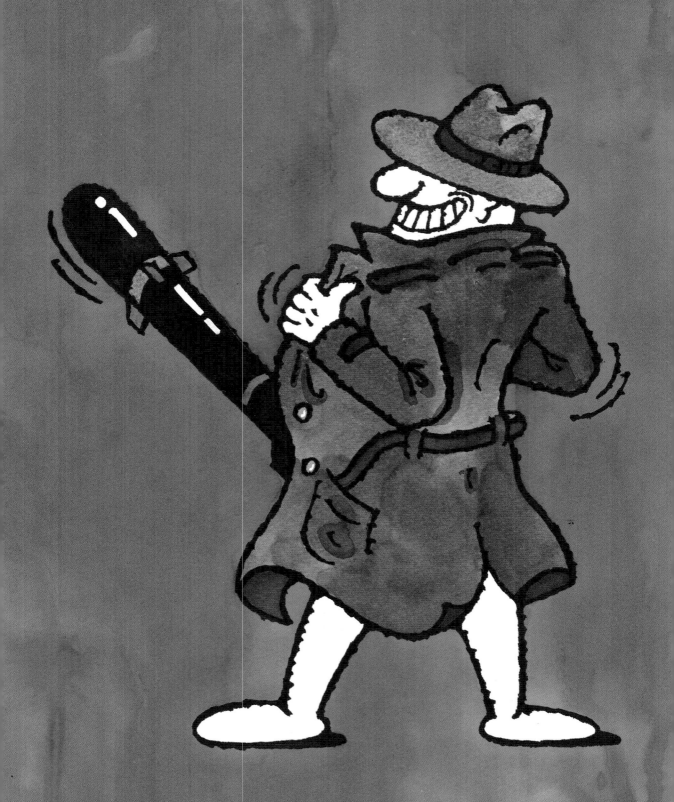

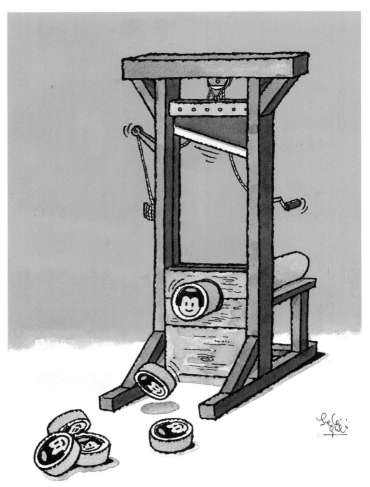

3.

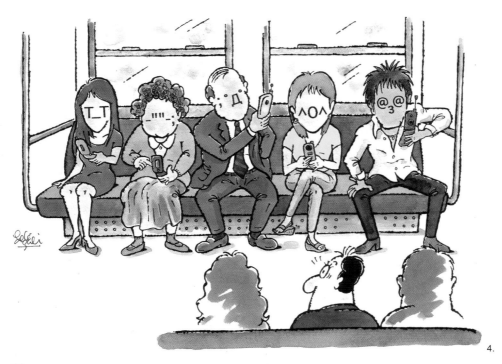

4.

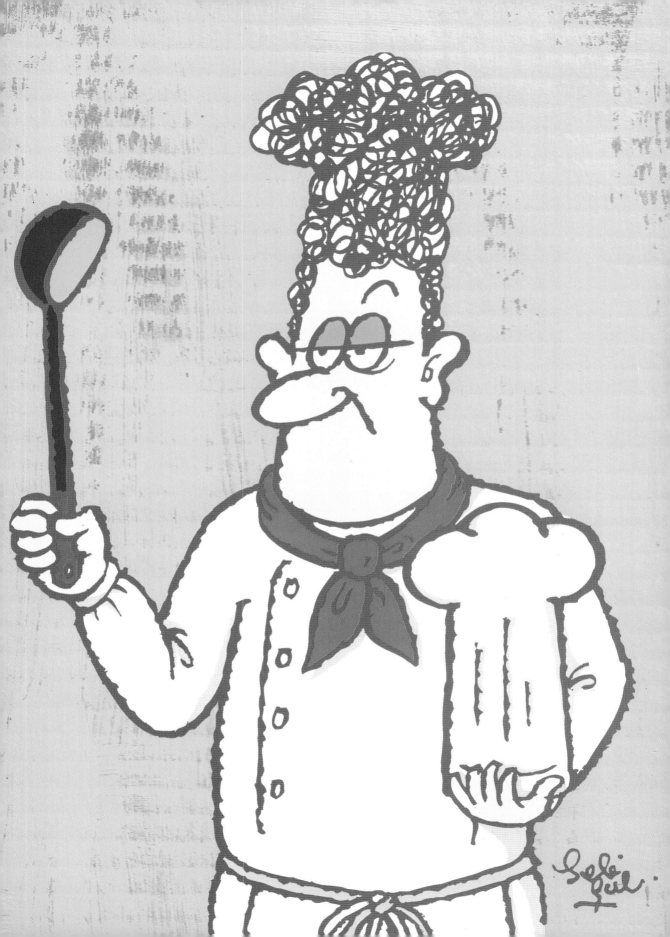

Mr. Kawano's insatiable curiosity has kept him motivated and, in his own words, he "looks, reads, listens, talks and, acts out: these are my principles in order to have my artistic sensitivity well maintained." Within the feast-or-famine climate of the Japanese creative industry, he has freelanced as a leading illustrator for several decades. Mr. Kawano has published six illustrated children's books with major publishers. He is also dedicated to creating illustrations for elementary school textbooks in Japan. He is a member of the Japan Children's Book Artists Society and a founder of the website for freelance illustrators called e-space.

CLIENTS: Hitachi, Yamaha Music Foundation, Konica Minolta Japan, Tsukuda Original, Mitsui Oil, Lion, Tokyo Gas, Sato Pharmaceutical, Mainichi Newspapers, Osaka Shoseki, and many more...

AWARDS & SHOWS: My Character Exhibition Award of Excellence and more... Selected exhibitions at Harajuku Sekiun Gallery (Tokyo) e-space; "Calendars and The Horizon of Imagination"; Yamawaki Gallery (Tokyo) e-space Exhibition; and many more...

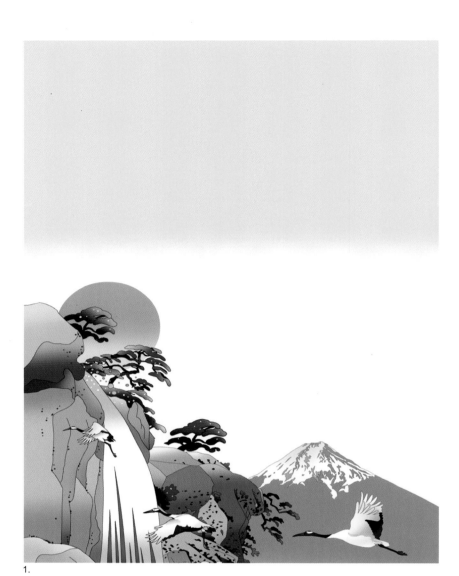

1.

Ryuji **Kawano**

Ryuji Kawano Econ. B.A., Kanagawa University
E-mail: ryuji_kawano@ARTas1.com **URL:** www.ARTas1.com/info/ryuji_kawano
Tools: Adobe Flash, Adobe Illustrator, Adobe Photoshop **Titles:** 1. a waterfall 2. wave 3. Mt. Fuji
4. Mt. Fuji in the Blue All images pages 22-23 © 2008 by Ryuji Kawano

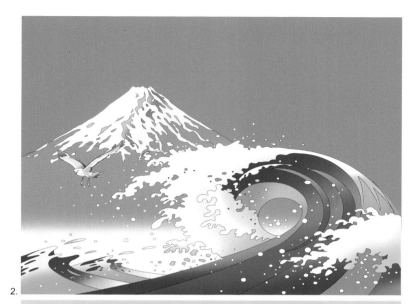

2.

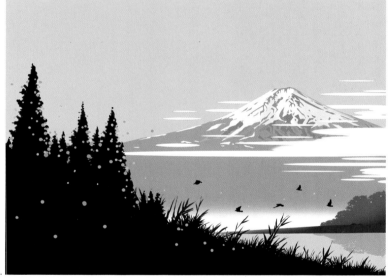

3.

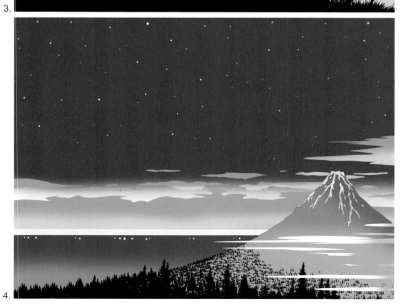

4.

"I perceive that manga and graffiti art are aesthetic symbols of creativity and they have contagiously spread across world cultures," says Mr. IMAITOONZ. He has created his own alternative formalism and expressionism in his character designs, manga/comics, and illustrations. For the internationally acclaimed animation film, *Dead Leaves* (now available in the U.S. and Europe on DVD), in collaboration with Production I.G, he did planning, screenplay, and character designs. His role in the creation of this movie has earned him an unparalleled reputation.

CLIENTS: NIKE Presto (animation), MTV Japan (Top of Japan opening animation), Reebok (Reebok x And A x IMAITOONZ model shoes), SEGA (arcade game *Fighting Vipers 2* character design), Medicom Toy (KUBRICK), Suntory, and many more....

AWARDS & SHOWS: The Ueno Royal Museum in Tokyo and Suntory Museum in Osaka Gundam: "Generating Futures" ('05); Labline TV (Tokyo) YUTOONZ 1st. MIX ('05); BEAMS Tokyo, Shibuya Parco Part 3 (Tokyo) "Devilman Illustration Exhibition"; Sapporo C.A.I. Gallery, and many more....

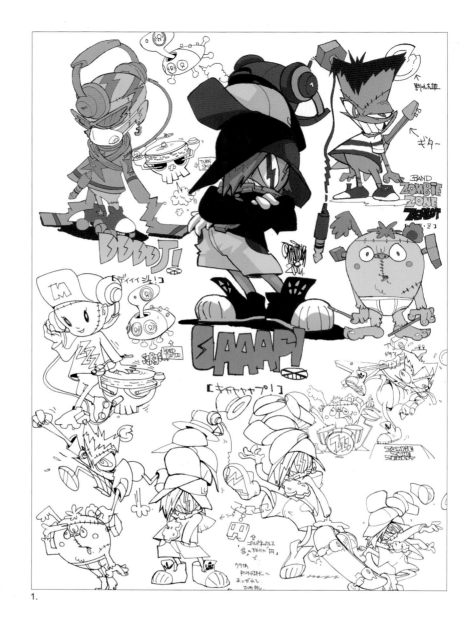

1.

IMAITOONZ

IMAITOONZ B.F.A., Tama Art University, Tokyo
E-mail: imaitoonz@ARTas1.com URL: www.ARTas1.com/info/imaitoonz
Tools: Adobe Photoshop CS2, Adobe Illustrator, pen Titles: 1. CAAAPI 2. dokomodake (P25)
3. Dr Pepper (P26) 4. town 5. future All images pages 24-27 © 2008 by IMAITOONZ

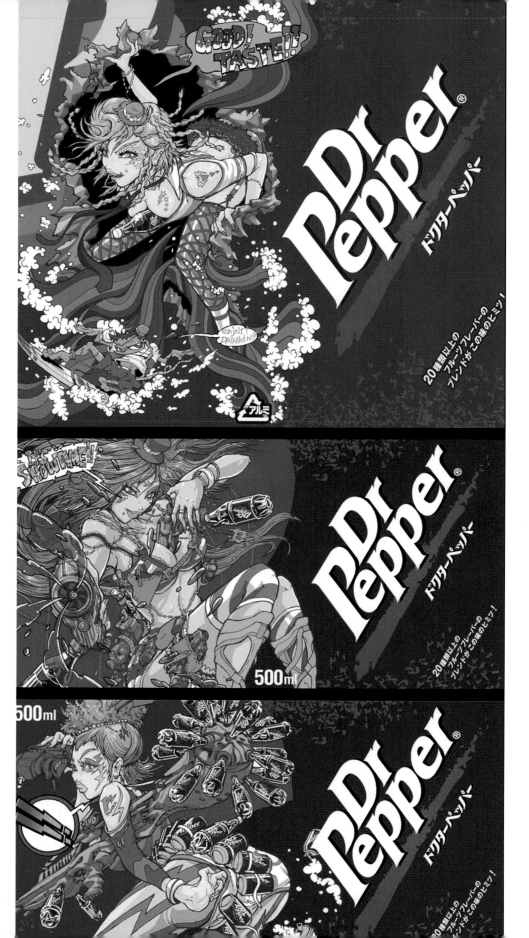

4.

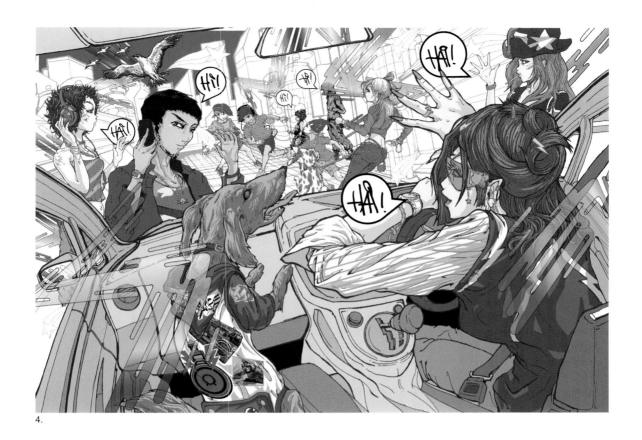

5.

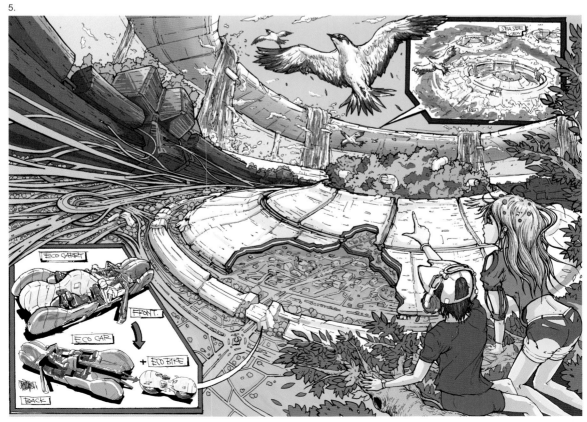

Mr. Nagano has gained celebrity for the covers he created among die-hard fans of *Star Wars* for the Japanese spin-off novels. Mr. Nagano's gigantic paintings have a dominating presence and possess an artistic luxury. Although his top-notch skills are arguably unparalleled, his modesty only permits him to say, "It is crucial to have great rivals who are talented to keep me motivated." Maintaining his passion for art and cementing his interest in his subjects are equally important for his creations. "In the future, I would like to do a Western history series and would like to work on more movie posters, despite the fact that the current trend is more toward using photos nowadays," says Mr. Nagano. Member of the Society of Illustrators and the Japan Publication Artist League.

CLIENTS: *Covers: Lucas Books and Sony Magazines* Star Wars *Japanese spin-off publications; Sekai Bunka Publishing* Sanguozhi (Three Kingdoms Saga), *and many more... Posters and illustrations; KOEI PC/online game series of* Nobunaga's Ambition *and* Romance of the Three Kingdoms; *Toho movie* Godzilla, Mothra and King Ghidorah: Giant Monsters All-out Attack *('01); and many more...*

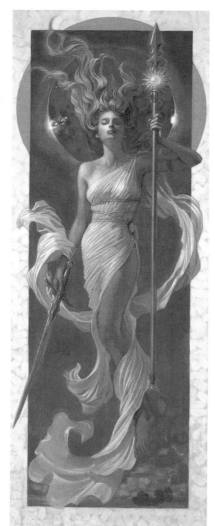

1.

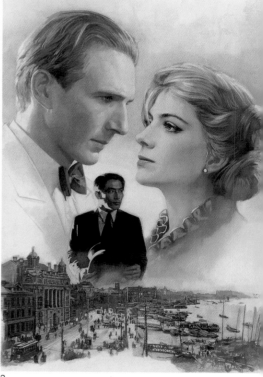

2.

Tsuyoshi **Nagano**

Tsuyoshi Nagano B.F.A., Nihon University College of Art, Tokyo
E-mail: tsuyoshi_nagano@ARTas1.com **URL:** www.ARTas1.com/info/tsuyoshi_nagano
Tools: Medium - Oil on canvas board **Titles:** 1. Prominence 2. The White Countess
3. The Legend of the King Nobunaga All images pages 28-29 © 2008 by Tsuyoshi Nagano

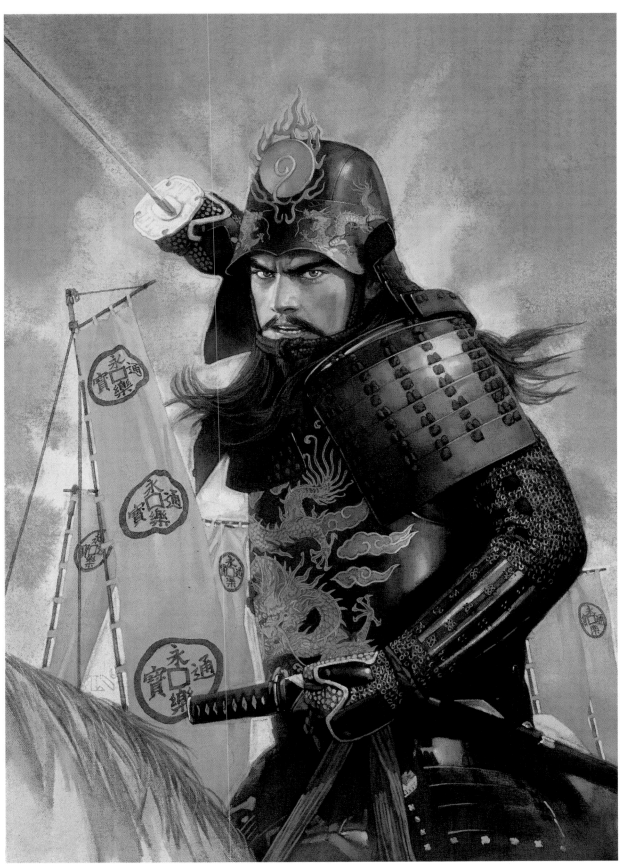

3.

Since leaving the largest design production house in Japan (Nippon Design Center), Mr. Kitatani has freelanced for several decades and has had a great impact on the industry. He is well known for his humorous animated clips for TV commercials as well as his editorial and print works. Mr. Kitatani always begins his creative process by drawing delicately with a glass pen on paper before he transfers his creations to the digital realm. He is a member of the Tokyo Illustrators Society.

CLIENTS: Dentsu, McCann Erickson Japan, Panasonic, Shiseido, Diners Club International (Citi Cards Japan), Suntory, The Body Shop Japan, Hakuhodo, ADK, Japan Broadcasting Corporation (NHK), and many more...

AWARDS & SHOWS: Aoyama Pinpoint Gallery (Tokyo) "Shigehisa Kitatani: Original Prints"; Museum für Kunst und Gewerbe, Hamburg; Marunouchi Café (Tokyo) "12 Days in New York"; Maison D'art "Shigehisa Kitatani: Joyeux Noël"; Aoyama Pinpoint Gallery "Shigehisa Kitatani: Etching Exhibition"; Vente Museum (Tokyo); Aoyama Pinpoint Gallery "Shigehisa Kitatani: Lithograph Exhibition", and more...

1.

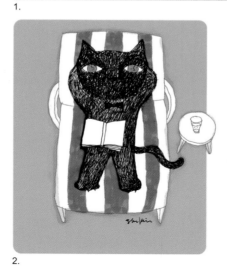

2.

kuroneko moboha kokkusan

junko takahashi + shigehisa kitatani
3.

Shigehisa
Kitatani

Shigehisa Kitatani Professor, Sagami Women's University
E-mail: shigehisa_kitatani@ARTas1.com **URL:** www.ARTas1.com/info/shigehisa_kitatani
Tools: glass pen, ink, Adobe Photoshop CS3 **Titles:** 1. Black Cat MOBO1 2. Black Cat MOBO3
3. Black Cat MOBO2 4. Mr. Violin All images pages 30-31 © 2008 by Shigehisa Kitatani

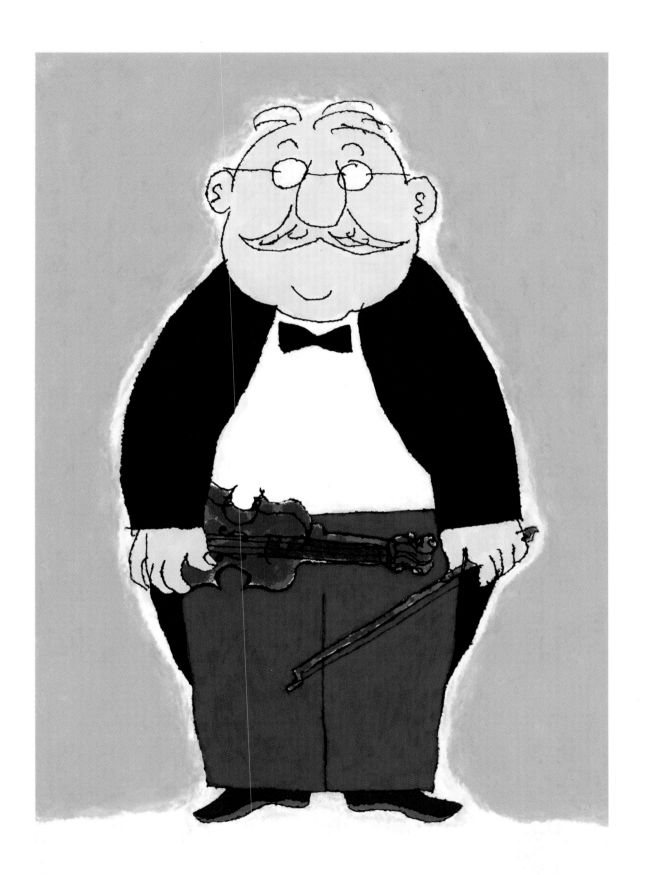

4.

Self-taught, Mr. KUNTA explores daily social life and societal ideals through animal figures. Achieving a gentle warm-heartedness in his often communal scenes, he works in many different mediums such as airbrush, paper cutout, drawing, and digital. The clean lines and attention to detail in his pieces are very recognizable. Member of the Society of Illustrators, the Japan Graphic Designers Association, and the Tokyo Illustrators Society.

CLIENTS: Visual promotions & product planning; Bridgestone, HITACHI, Honda Verno Shintokyo, Unilever Japan, Tokyo Dome, and many more... Covers and Illustrations: Shueisha, Kodansha, Recruit and many more... Publications: Artist book PIPaRIPaRa WORLD.

AWARDS & SHOWS: New York Museum of American Illustration - "Gallery 1 Thirteen" ('96); The Society of Illustrators Member's Gallery "Three Japanese Members" ('99); Tokyo Illustrators Society Exhibition in France; Japan – Korea Cultural Exchange Hall in Seoul Japan – Korea Group Exhibition; Oji Paper Gallery (Tokyo); Mitsumura Art Plaza (Tokyo); International Design Center in Nagoya, and many more...

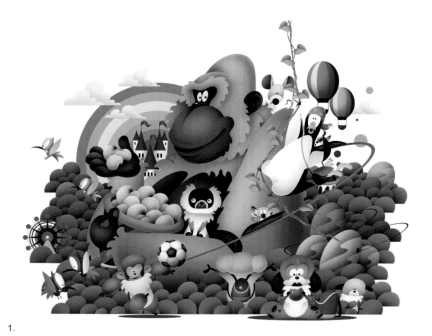

1.

KUNTA

KUNTA
E-mail: kunta@ARTas1.com URL: www.ARTas1.com/info/kunta
Tools: Adobe Illustrator, Adobe Photoshop, pen, paper, sculpture, airbrush, acrylic ink
Titles: 1. GORILLAND 2. Extinct Animals Expedition 3. HANZO&POCKETS TOWN (P34)
4. MIJINCO ROCK (P35) All images pages 32-35 © 2008 by KUNTA

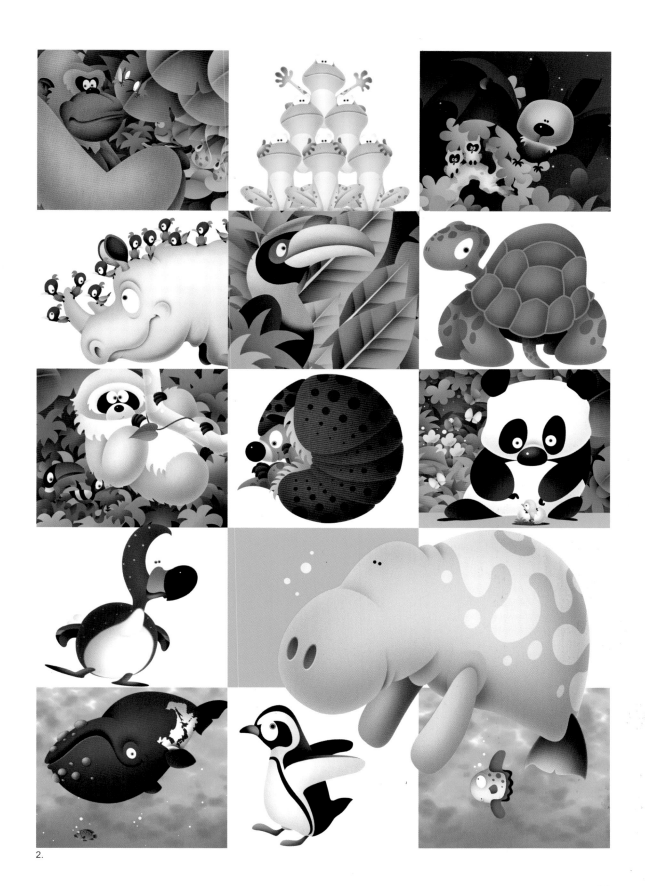

2.

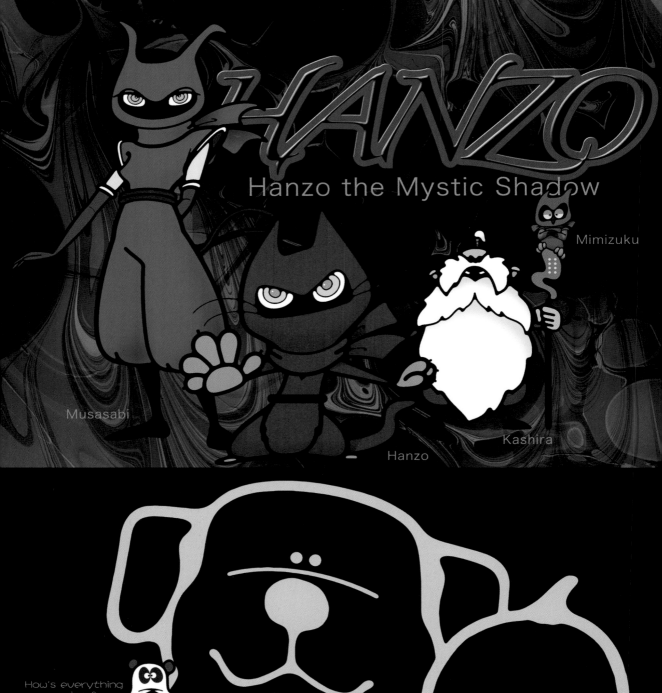

HANZO
Hanzo the Mystic Shadow

Mimizuku

Musasabi

Hanzo

Kashira

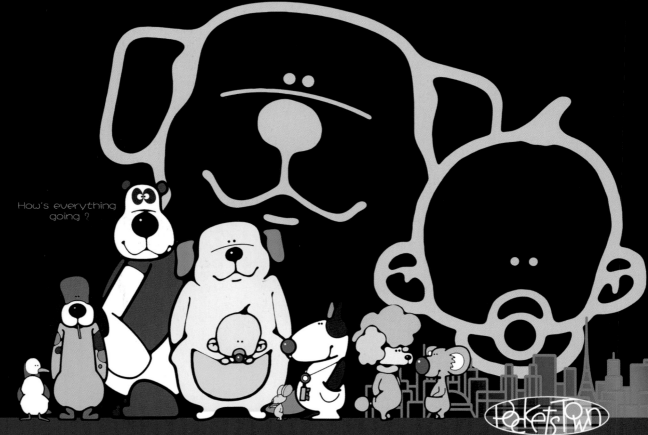

How's everything going?

pocketsTown
We have happy pockets.

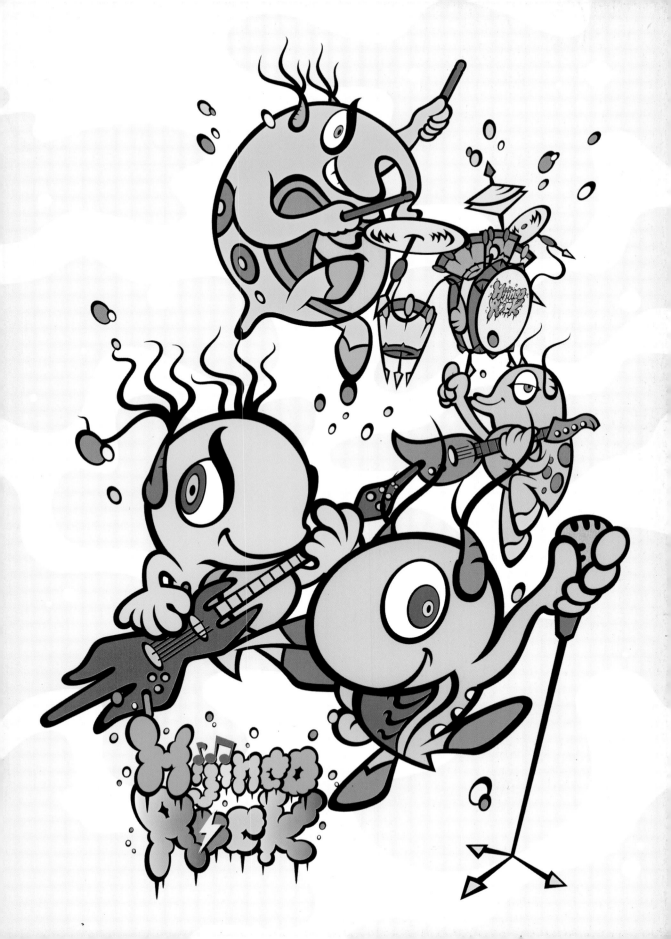

1.

Mr. Yokota creates images that capture "blissful seasons," instilling them with the spirit of everyday life and the idea of "living in the present." His illustrations are created and processed digitally in order to render a subtle play of light and color gradation while lending them the appearance of hand-drawn pastels. Mr. Yokota's works have appeared in numerous books, magazines, and calendars. His expertise in making piezo graph prints is also highly acclaimed. Member of the Society of Illustrators.

CLIENTS: Visa Japan, Silver Editions (USA), Sunrise Greetings (USA), Asahi Shimbun Newspaper, Oji Paper, and many more...

AWARDS & SHOWS: Annual Entries to the Society of Illustrators; One-man exhibitions at Oji Paper Gallery Ginza every year since 1994; Museum of American Illustration – Member's Gallery "Three Japanese Members" ('99); Museum of American Illustration – "Gallery 1 Thirteen" ('96); "Dazzle" Aoyama; and many more... Museum of American Illustration – "Gallery 1 NIPPON" ('03); Museum of American Illustration – "Gallery 1

Hiromitsu
Yokota

Hiromitsu Yokota Fine Arts B.A., Musashino Art University, Tokyo
E-mail: hiromitsu_yokota@ARTas1.com **URL:** www.ARTas1.com/info/hiromitsu_yokota
Tools: Corel Painter X **Titles:** 1. Hawaiian Moon 2. WA (Japanese Style) 3. Calender 4. Jungle Moon
5. Japanese Scenery 6. Mysterious Beach All images pages 36-39 © 2008 by Hiromitsu Yokota

A lifestyle of Japan

2.

3.

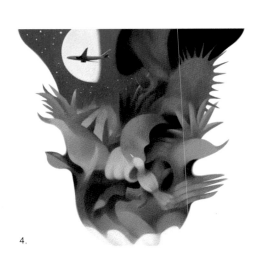

4.

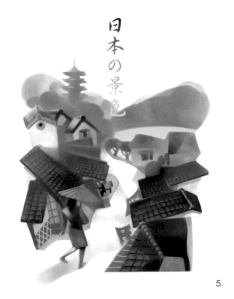

日本の景色

5.

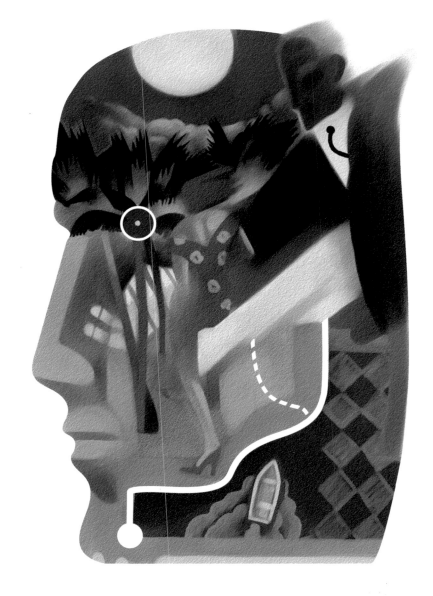

6.

Kimi's works capture the rippling play of light and water in swimming pools. Exploring the dimensions of water, light, and time, his installations submerge his audiences in fluid atmospheres. "I hope audiences can feel the strength, warmth, and tenderness of the water when experiencing my art," says Mr. Tsuji. He also aspires to produce site-specific installations in hotels, bars, and cafés throughout the world, where the public can be energized by his works.

CLIENTS : Art Print Japan, and more.... Mr. Tsuji has also worked on stage design for several theatrical shows.

AWARDS & SHOWS: Solo shows at ATELIER K (Yokohama) "Alive Blue"; WAVES (Kanagawa) "Blue Heaven"; Iwasaki Museum (Yokohama) "Innocent Blue" (sponsored by KODAK & Kirin Brewery); Graphic Station (Tokyo) "Silent Blue"; Yokohama International School (art collaboration event); and many more...

1.

Kimiyuki **Tsuji**

Kimiyuki Tsuji
E-mail: kimiyuki_tsuji@ARTas1.com **URL:** www.ARTas1.com/info/kimiyuki_tsuji
Tools: under water camera, Mixed Media **Titles:** 1. laughing gold 2. saboten (cactus)
3. kin no awa (gold bubble) 4. hikari (luster) All images pages 40-41 © 2008 by Kimiyuki Tsuji

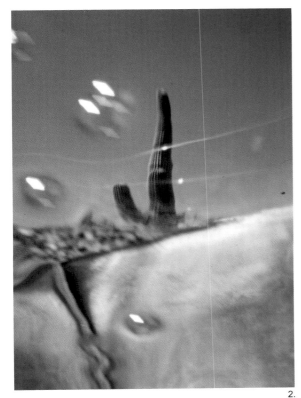

2.

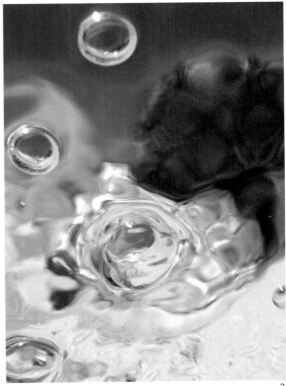

3.

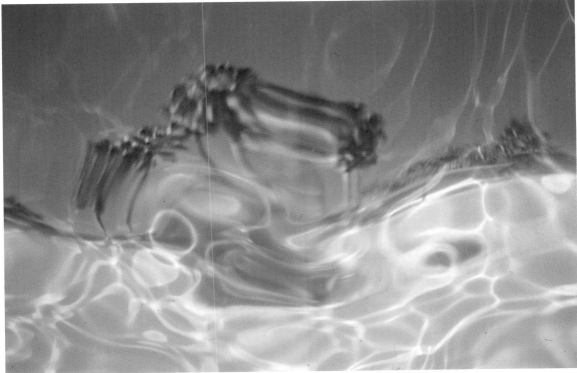

4.

Highly regarded as an art director in New York and Tokyo, for the past decade Mr. Hiro-Shi has collaborated with several high-profile international clients from all kinds of industries. Recently, he has also embarked on a successful career as a visual artist. "There is no need to hold on to a specific medium or material, no need to categorize styles of visual art, much less the method of making it. No matter what it takes to make it, photographs or illustrations, visual art should communicate," he says. With this philosophy, Mr. Hiro-Shi wants to craft visual art rather than design it. It is crucial for him to create visual art with a strong expression because his goal is to have his audiences feel the works, and remember that feeling. He knows that his visual arts will eventually turn into commoditized properties, but he still "strives to craft the human state of mind."

AWARDS & SHOWS: Numerous international advertising awards.

1.

Hiro-Shi

Hiro-Shi
E-mail: hiro-shi@ARTas1.com URL: www.ARTas1.com/info/hiro-shi
Tools: color pencil Titles: 1. Brotherhood 2. Humanity 3. LOVEMEBIUS™ Logo 4. Love of Nature
5. Parent-child Love (A Stroke Draw) 6. Forever Love 7. Parent-child Love (A Stroke Draw)

2.

3.

4.

5.

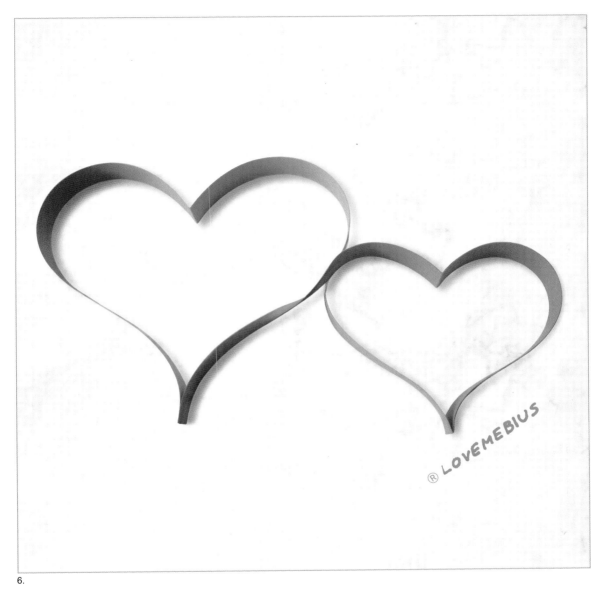

6.

7.

Combining her professional experience in the fields of graphic design and apparel design, Ms. Saike investigates the artistic possibilities of fabric. Her collages are an assemblage of appliqué and computer generated images, transferred onto hand-woven, hand-dyed cloth. Her works can be called paintings, but they are in fact painted with fabric and accompanied by layers of appliqué that evoke a unique world. Ms. Saike enjoys studying the various color combinations in this world of hers, sometimes for years at a time.

AWARDS & SHOWS: Ms. Saike has been selected for several group shows.

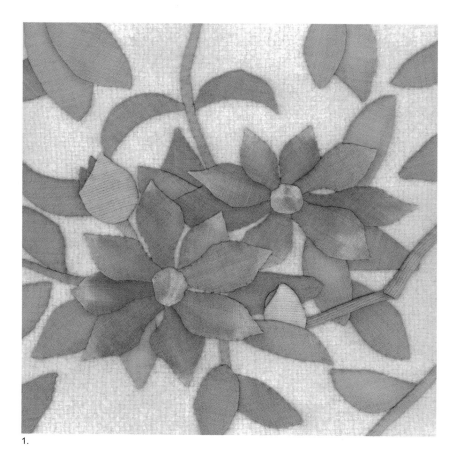

1.

Eri **Saike**

Eri Saike Design B.A., Tama Art University, Tokyo.
E-mail: eri_saike@ARTas1.com **URL:** www.ARTas1.com/info/eri_saike
Tools: Adobe Illustrator, Adobe Photoshop **Titles:** 1. Clematis 2. Tulip 3. Flower 1 4. Flower 2
5. Various Weavings (P49) All images pages 46-49 © 2008 by Eri Saike

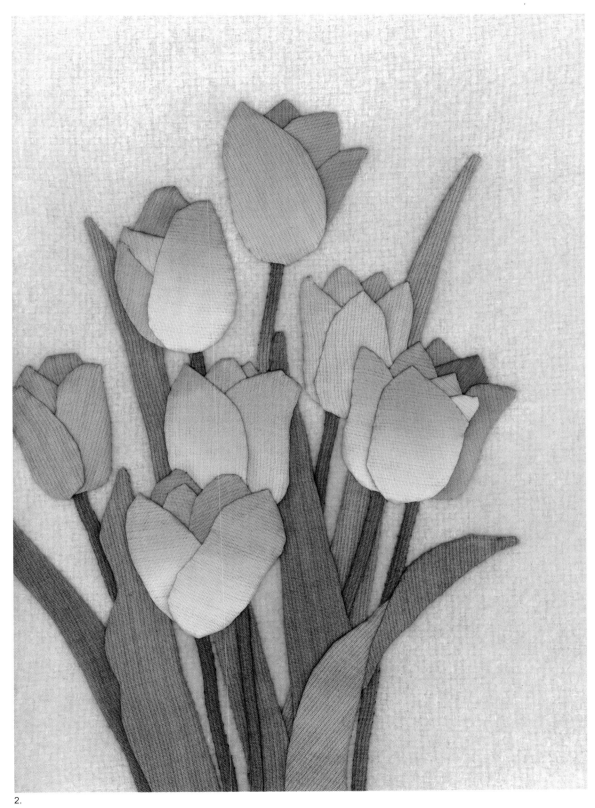

2.

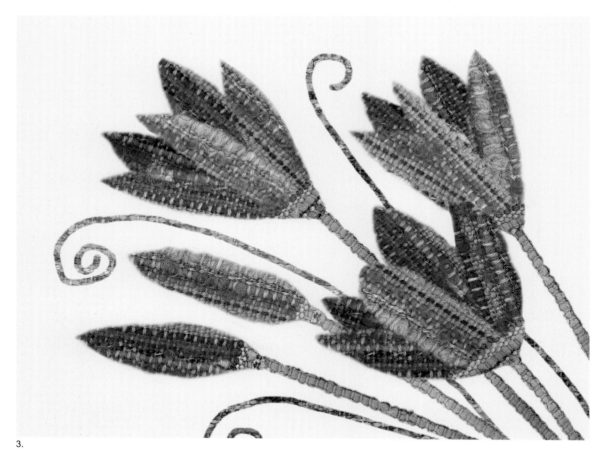

3.

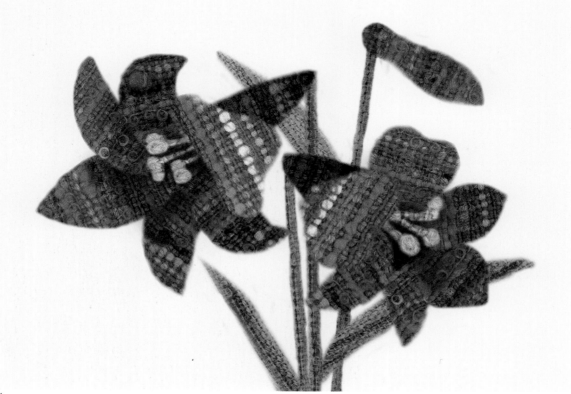

4.

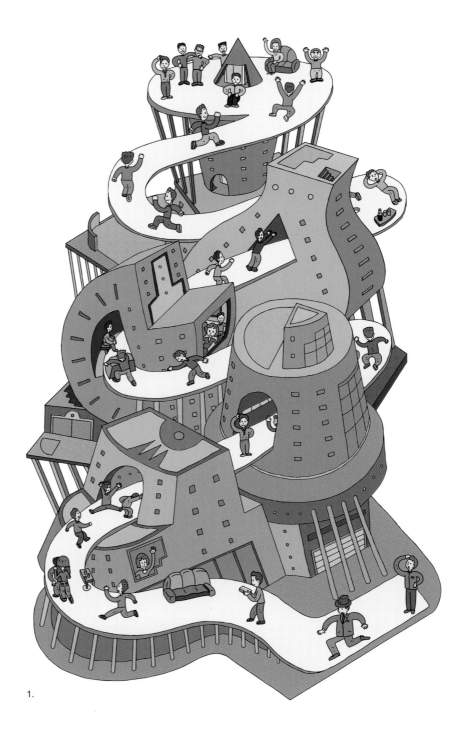

Being free from technical rules and commonplace theories of art is critical to Mr. Watanabe's creative process. A street scene with architecture is purposely delineated "out of perspective" and his geometric shapes are drawn organically, freehand. He finishes his works digitally, employing the computer as an essential tool in the same way that a painter uses pencils, brushes, and pallets. Mr. Watanabe gives his worlds individuality with a rhythm of colors and textures, and a harmony in composition.

CLIENTS: Covers, editorial illustrations and layout designs for major Japanese publishers including Gakken, Nihon Bunkyou Shuppan, Nippon Jitsugyo Publishing, Toyo Keizai, Gijutsu-Hyohron, and many more...

1.

Hal
Watanabe

Hal Watanabe Design B.A., Musashino Art University, Tokyo
E-mail: hal_watanabe@ARTas1.com **URL:** www.ARTas1.com/info/hal_watanabe
Tools: Illustrator CS3, Photoshop CS3 **Titles:** 1. COPD 2. night watch 3. on demand 4. camera

2.

3.

4.

51

Ms. Nomura's artworks indicate physical and metaphysical spaces of contemplation. In conjunction with a richness of hues and grace of forms, her abstract worlds explore unconventional pictorial signs. Her works have appeared in various promotional posters, prints, and publications. In the future, Ms. Nomura is looking forward to taking on the challenges of picture books, theatrical designs, and large installations. She is a member of the Tokyo Illustrators Society.

CLIENTS: The Windsor Hotel TOYA, JR Tokai Agency, Mainichi Communications, Takeo Paper Company, Kanou Shoujuan, and many more...

AWARDS & SHOWS: Illustration CHOICE Prize, and more... Exhibitions at The Tokyo Illustrators Society Creation Gallery G8 (Tokyo), YURINDO Gallery (Yokohama), and many more...

1.

2.

Miyako
Nomura

Miyako Nomura Design B.A., Tama Art University, Tokyo Design M.A., Tokyo National University of Fine Arts and Music
E-mail: miyako_nomura@ARTas1.com **URL:** www.ARTas1.com/info/miyako_nomura
Tools: acrylic paint, Japanese paints, texture gel, watercolors **Titles:** 1. Bright Spring Blooming
2. Japanese Hagi (bush clover) 3. flower 4. leaf 5. pitfall All images pages 52-53 © 2008 by Miyako Nomura

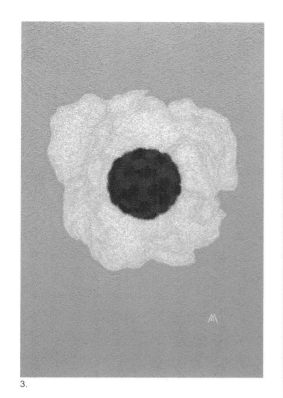

3.

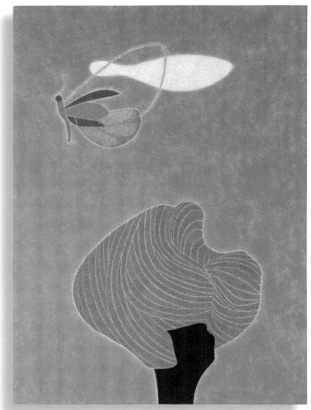

4.

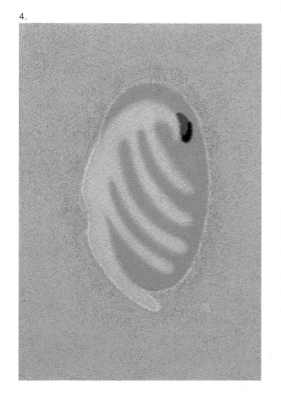

5.

CLIENTS: Japan Broadcasting Corporation (NHK), Online Shop Mutow, Kintetsu Department Store, Kikuchi Optometry, TV - Aichi, and many more...

AWARDS & SHOWS: She has joined in various selected group shows and annually participated in the Nagoya Illustrators Club Exhibition.

Quirky worlds made of unconventional materials are Ms. Suganuma's specialty. She works by trial and error to crystallize her ideas into a three-dimensional reality, choosing materials with appealing sculptural presence. Whether in the two-dimensional or three-dimensional realm, her illustrations promise to entertain audiences and this, she feels, is the primary goal of commercial illustration. Her works have appeared in various advertising campaigns and on television programs.

1.

2.

Miwa
Suganuma

Miwa Suganuma B.F.A., Nagoya University of Arts
E-mail: miwa_suganuma@ARTas1.com URL: www.ARTas1.com/info/miwa_suganuma
Tools: Mixed Media, Adobe Photoshop Titles: 1. E-Mail Gang 2. Animation - 5 3. Twinkle! (P55)

"To work happily I need to keep myself in a neutral state... then I can create true images. When I work on a project, it is the *yohaku* (the blank space) that I am vividly aware of. *Ma* and *kuki* (the space and air between things) are universal in compositions and I think everyone can perceive this." With fluid forms made from rich brush strokes, Ms. Inazawa's illustrations possess a distinguished grace. Her works have appeared in character designs, calendars, and picture books, and they all have a special warmth that reaches out to audiences. Ms. Inazawa also enjoys her gift and established reputation in calligraphy.

CLIENTS: JALUX (JAL Group) and Japan Airport terminal (lunch box packaging), CO-OP, Polan Organic Foods Delivery, Kamakurayama Natto, and many more...

1.

Mihoko
Inazawa

Mihoko Inazawa Design B.A., Tama Art University, Tokyo
E-mail: mihoko_inazawa@ARTas1.com URL: www.ARTas1.com/info/mihoko_inazawa
Tools: sumi, watercolor, Adobe Illustrator, Adobe Photoshop Titles: 1. water 2. wind 3. wind 4. tree 5. Japanese Spirits "WA" 6. mustard 7. bean 8. potato 9. fruit 10. chestnut 11. fish 12. dance 13. fish 14. sake 15. clock All images pages 56-59 © 2008 by Mihoko Inazawa

2.

3.

4.

5.

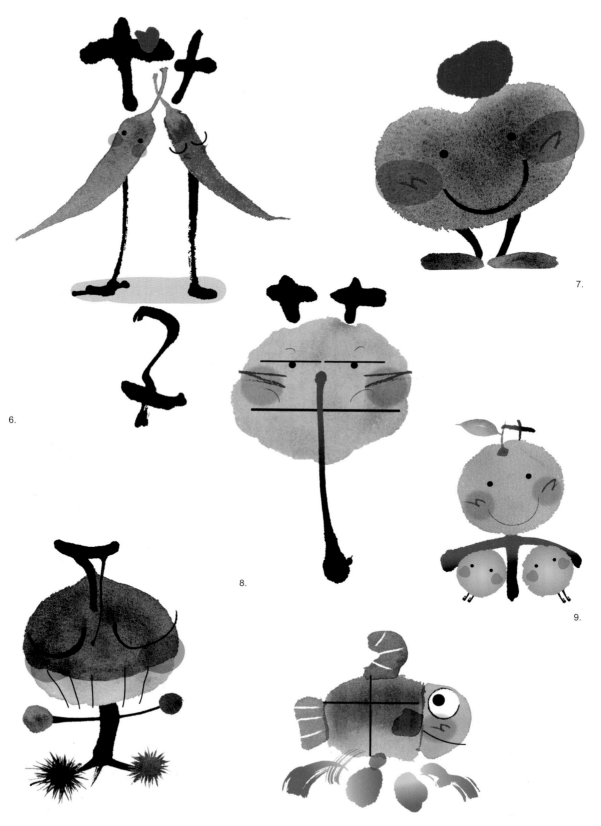

6.

7.

8.

9.

10.

11.

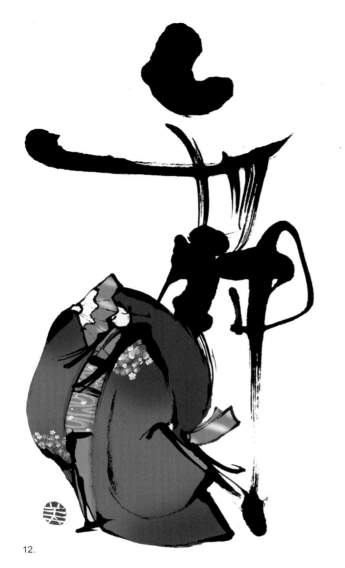

12.

13.

14.

15.

CLIENTS: Toyota, Seikatsusoko, Oasis 21, Murasaki Sports, ZIP-FM (Nagoya), DYNALAND, and many more...

AWARDS & SHOWS: Menlo Highest Award ('97), Exhibition "New Yorker Minute" (2008)

As an emerging illustrator, Mr. Yamamoto has rapidly gained a reputation and expanded his clientele into the fields of commercial animation, magazines, and advertising. Transcending culture and nationality, his art represents the universal hipness of Japan as well as its sensitivity, with a mix of graffiti and fine art styles. Bold lines and vivid colors are vital parts of his creations. Mr. Yamamoto worked and lived in New York City for three years and recently returned to Tokyo.

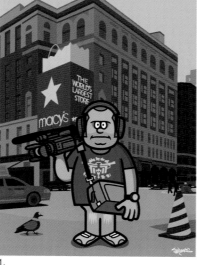

1.

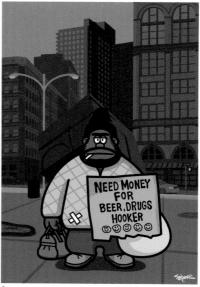

2.

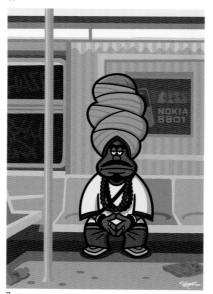

3.

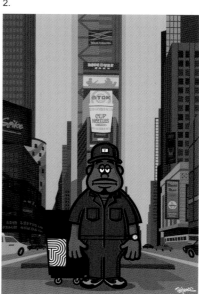

4.

Shuji
Yamamoto

Shuji Yamamoto
E-mail: shuji_yamamoto@ARTas1.com URL: www.ARTas1.com/info/shuji_yamamoto
Tools: Adobe Illustrator, Adobe Photoshop Titles: 1. cameraman 2. need money 3. big head
4. worker 5. New Yorker Minute

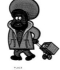

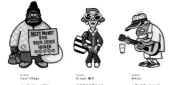

SHUJI YAMAMOTO'S 1st EXHIBITION
08.2.11(MON)⇒17(SUN) at SPACE INTART

Yamamoto had taken an active part as an illustrator based on Nagoya before.
He visited America all alone for the creative impulse in April, 2004.
And, his atelier was moved to the Queens district in Manhattan outskirts.
To go to where, Yamamoto carried about the digital camera in New York for three and a half years until 2007 while staying.
He took a picture of unique "New Yorkers" with the camera in the place.
And, he sketched them by an original aspect. In addition, he made it to the character.
New Yorkers that Yamamoto draws is not a fiction at all.
They are realistic people, and if you walked in Manhattan, you will be able to encounter them.

In this one-man show "New Yorker Minute"
The characters tell you "the present of New York" that Yamamoto has experienced.
Please enjoy and see.

New Yorker Minute

5.

"I like to infuse universality into the individuals in my work so that audiences can project their own feelings." Using sophisticated images, Ms. Mitsumi's illustrations evoke a cinematic approach, in which each protagonist conveys intricate emotions yet addresses the audience serenely. Her works are the result of an elaborate process that begins with painting acrylic on canvas, scanning the painting, and finishing up digitally. She has collaborated with various clientele in editorial, broadcasting, IT, and advertising for major corporations. Her illustrations were selected by *Illustration Now!* (published by TASCHEN, editor: Julius Wiedemann) which showcases commercial and editorial illustrators from over fifty countries.

CLIENTS: Columbia Music Entertainment, Kellogg Japan, Toshiba, GQ Japan, Shiseido, DHC, Kadokawa Shoten Publishing, Kodansha, Shueisha, Tokuma Shoten Publishing, Nihon Keizai Shimbun, The Asahi Shimbun, SoftBank, Infobahn, Impress, AIG(Japan), Diamond, Inc., Gentosha, Magazine House, and many more...

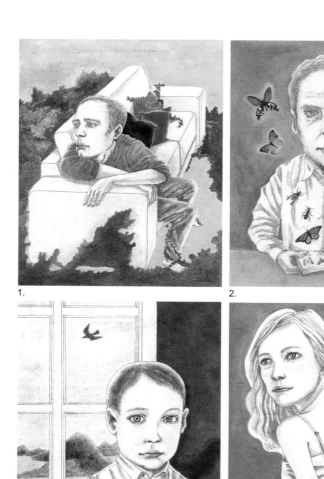

1. 2.
3. 4.

Mari **Mitsumi**

Mari Mitsumi
E-mail: mari_mitsumi@ARTas1.com URL: www.ARTas1.com/info/mari_mitsumi
Tools: acrylic on canvas, Adobe Photoshop (painted with acrylic on canvas and scanned, then finished up digitally by Adobe Photoshop) **Titles:** 1. A 100 days off 2. It's all in your mind
3. Look at the bird 4. April-March 5. Tangible (P63) All images pages 62-63 © 2008 by Mari Mitsumi

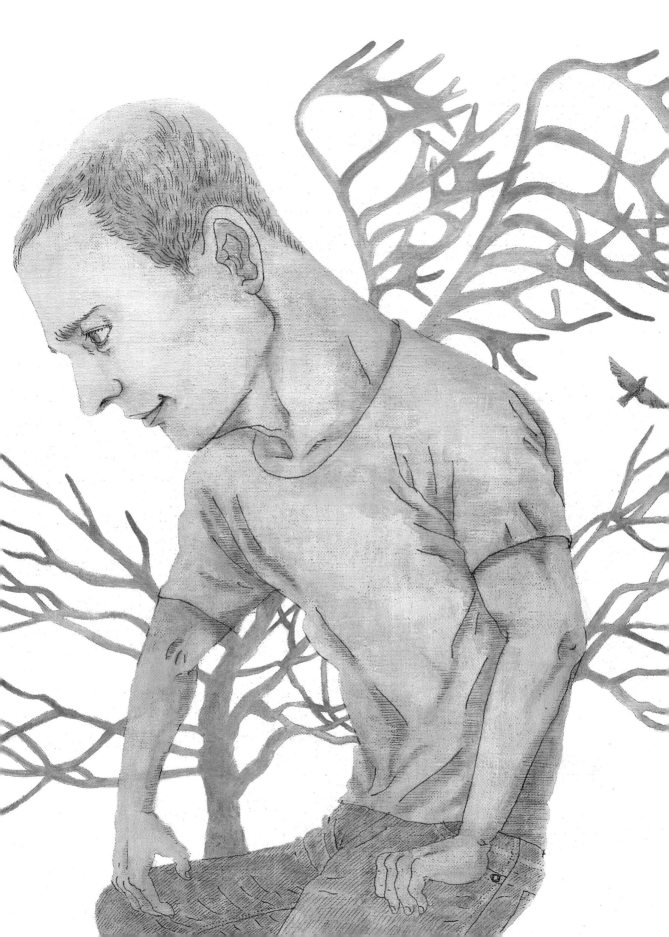

Born in Japan in 1970, Ms. Tsutsui is a self-taught artist who has worked as a freelance illustrator for publications, advertising and other fields since 1995. The following year, in 1996, she transitioned away from air brush to work exclusively on the computer, developing her unique digital techniques. Today, everything from the first draft to completed product is 100% CG. While she is active in many fields, she is most well known for her 2D character illustrations. Ms. Tsutsui first came on the international scene in 2006 with exhibitions of her works in both New York and Paris.

CLIENTS: Toshiba I.S. Corporation, Softbank, Benesse Corporation, CoMix Wave Films Inc. MagazineMagazine, Shogakukan, Tatsumi Publishing Co., Ltd., Iwasakishoten, Gakken, Ponycanyon, Sun-Star-Stationery, Sun&Star, Daiichi-Shokai, Tenyo, Natsumesha Co., Ltd., Seika Co., Ltd., Works Corporation Inc., and many more...

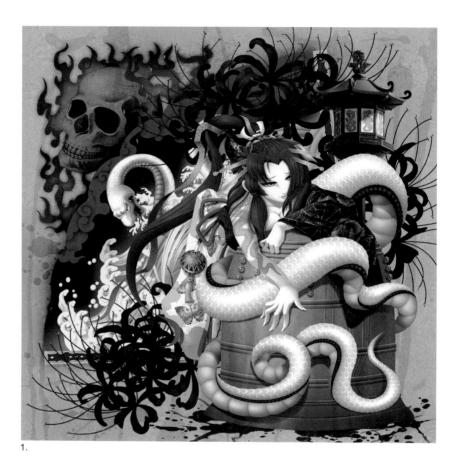

1.

Misa **Tsutsui**

Misa Tsutsui
E-mail: misa_tsutsui@ARTas1.com URL: www.ARTas1.com/info/misa_tsutsui
Tools: Corel Painter Titles: 1. Kiyohime 2. Hero of Edo (P65) 3. Kujyakumyo-o (P66)
4. Fudomyo-o (P67)

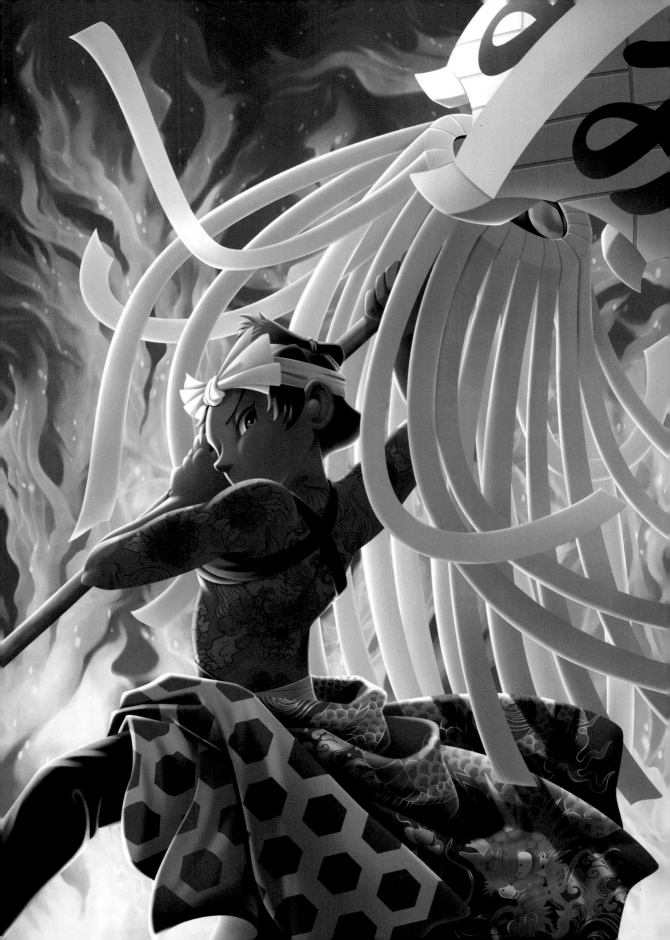

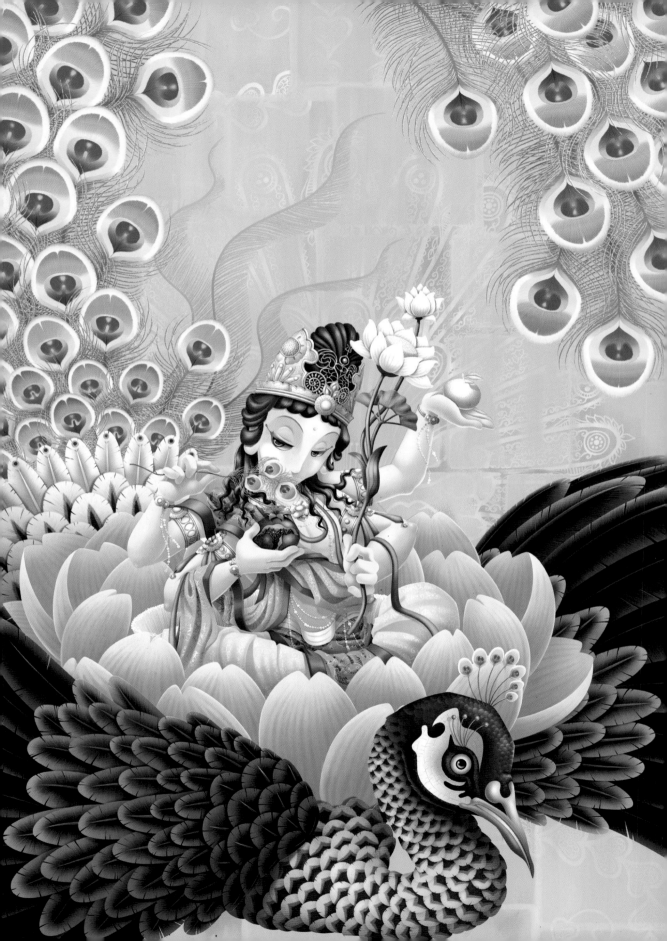

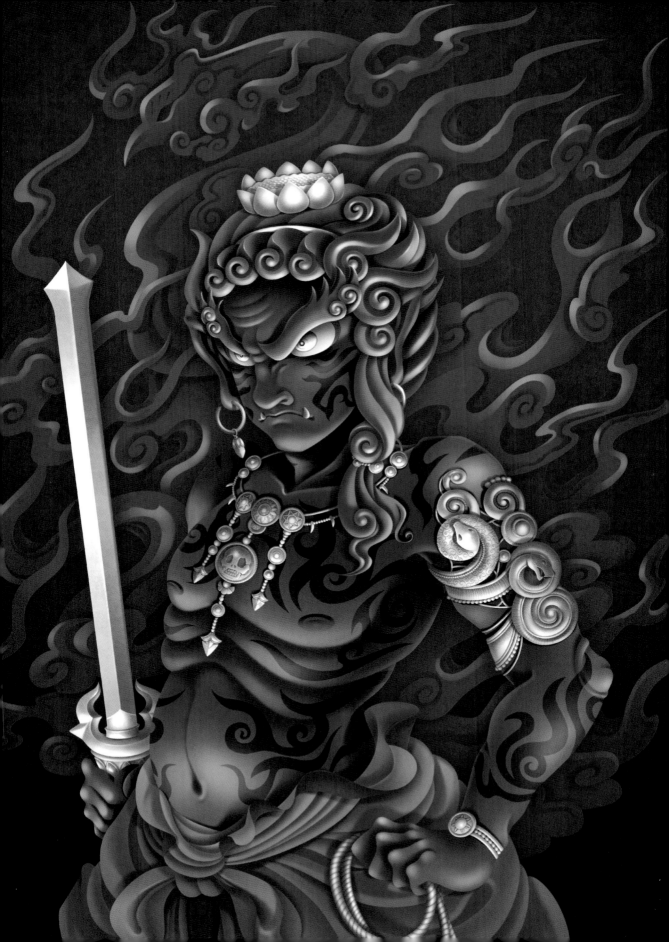

The header logo reads "ARTas1". The vertical text is a biography rotated.

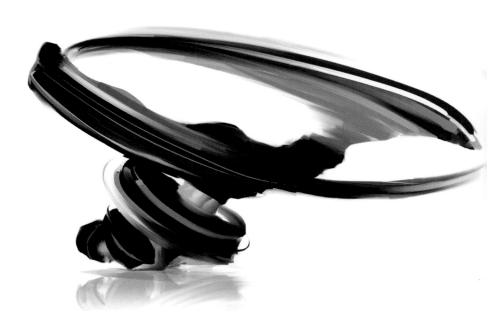

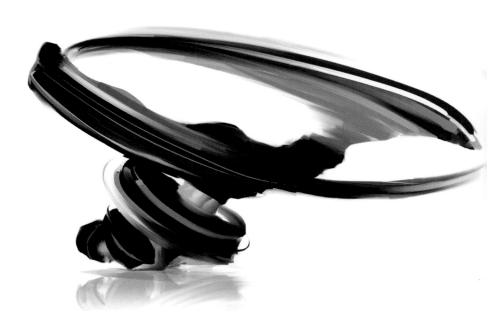

ART as 1

Mr. Yamashita creates digital paintings with the consistent theme of *yakudo*, which means, translated literally, "full of life and energy." Like the climactic moment in a film, his paintings are iconic, explosive, energetic, and memorable. Yamashita's unique fisheye lens perspective adds to his works' depth, breadth, and beautiful trajectory lines, creating this dramatic effect of *yakudo*. Mr. Yamashita started working as a caricaturist when he was a student. In 2002, he became an illustrator based in Yokohama City. After passing the Digmeout Audition, a rite of passage for many of Japan's young art leaders, he embarked with his theme of *Yakudokan* into the art world on a quest to go beyond the realm of illustration.

Awards & Shows: Awards: "Caricaturist of the Year" 1st place at NCN Convention 2005 in Las Vegas (2005); "Caricaturist of the Year" 2nd place at NCN Mini Convention 2007 in Tokyo (2007); Passed Digmeout Audition (2008); Exhibitions: "cre8 NY11" Exhibition at NYCoo Gallery (2006); "NYG Exhibition" at Gallery Konrin (2007); "My Favorite 6" Exhibition at Fujiya Hotel (2007)

Clients: Harley-Davidson Japan K.K., NIKE JAPAN, Benesse Corporation, MAGAZINE HOUSE, Ltd., and many more...

1.

Ryohei
Yamashita

Ryohei Yamashita Visual Communication Design B.A., Kyushu Institute of Design
E-mail: ryohei_yamashita@ARTas1.com URL: www.ARTas1.com/info/ryohei_yamashita
Tools: Adobe Photoshop, Corel Painter, acrylic Titles: 1. Wind Mill 2. Rave (P69) 3. Like A Rolling Stone 2
4. Baseball Star(NIKE JAPAN) 5. Rock Star 3 (P71) All images pages 68-71 © 2008 by Ryohei Yamashita

68

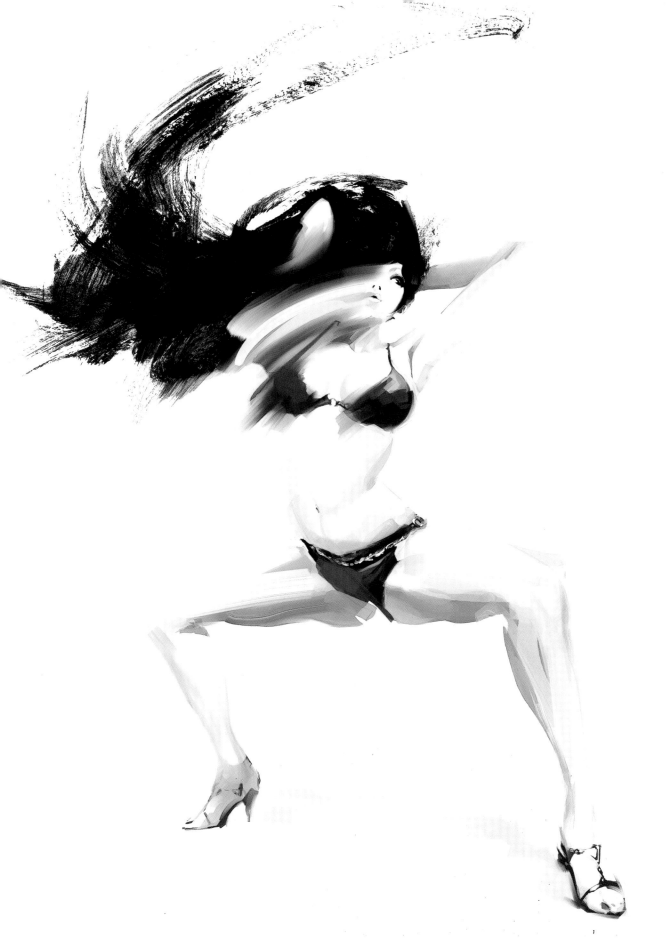

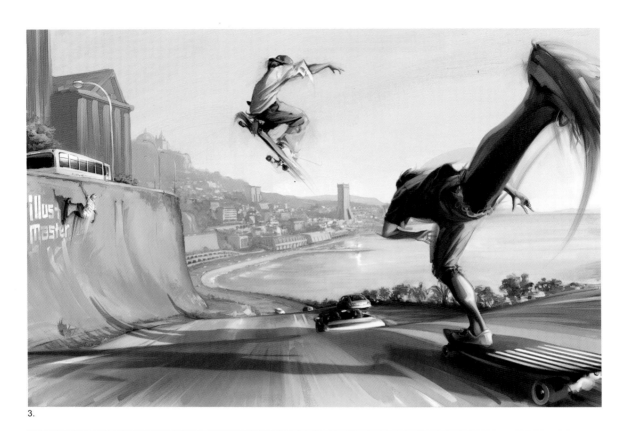

3.

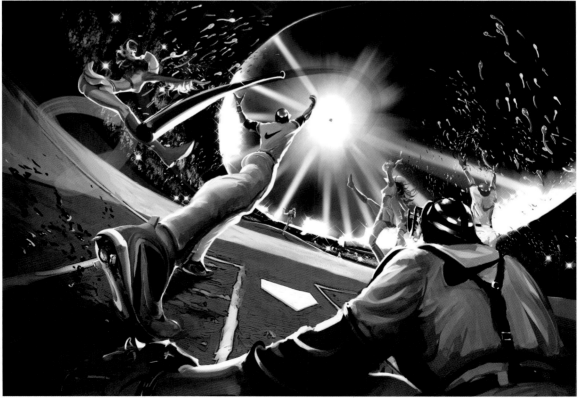

4.

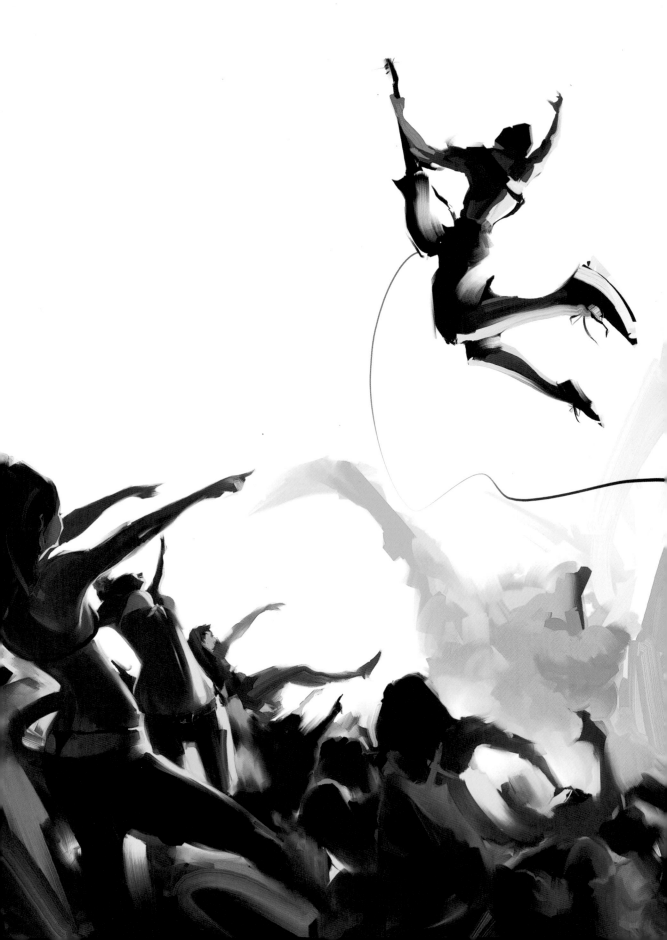

ᑎRT as 1®

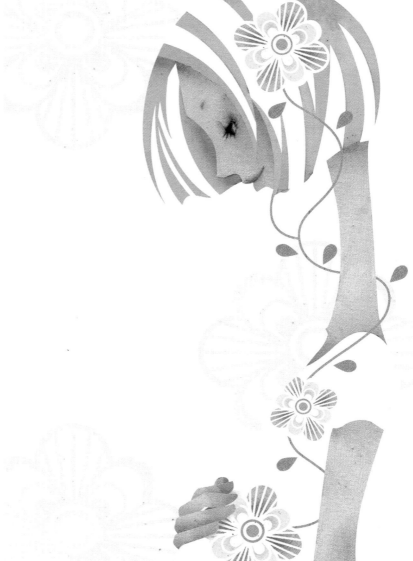

1.

Ms. morori began her study of design in 1995. She worked in the game industry until 2004 when she began her career as a freelance artist in Tokyo. She wishes to involve people through her illustrations and creations, in which she has a policy of drawing a world in a way that photos cannot express.

"I put my heart and love into every motif. I make a new creation every day so that I may create a new world."

CLIENTS: Sony Music, OZ Mall, Starts Publishing Corp., Caz, DHC Corp., Gijutsu-Hyohron Co., Ltd. and many more...

AWARDS & SHOWS: Selected in ART BOX 22nd Illustration Final Audition; Semi-Finalist in 5th CWC "Chance" Exhibition; Illustrators File Original Print Exhibition at Aoyama OPA Gallery (2006); Two Peron Exhibition LITERERGE at Gallery Lele (2007); Group Exhibition "Girls" at Ginza Mireya Gallery (2007); Illustrators File Original Print Exhibition at Aoyama OPA Gallery (2007); and many more...

morori

morori Graphic Design B.A., Tama Art University, Tokyo
E-mail: morori@ARTas1.com **URL:** www.ARTas1.com/info/morori
Tools: base, sheeting, acrylic gouache, Mixed Media, Adobe Photoshop **Titles:** 1. 6
2. untitled 3. smoke 4. untitled 5. untitled (P75) All images pages 72-75 © 2008 by morori

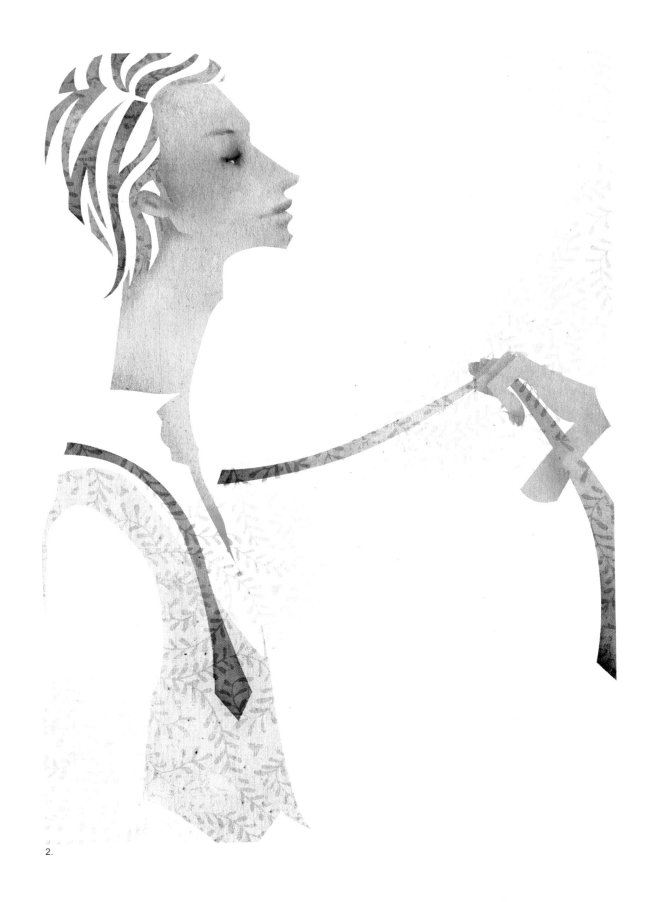

2.

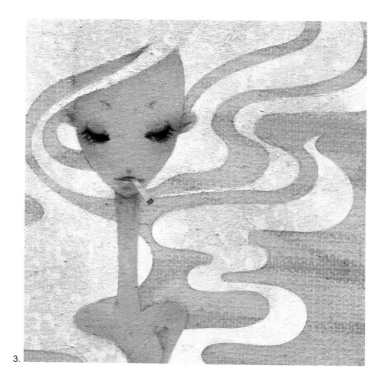

3.

4.

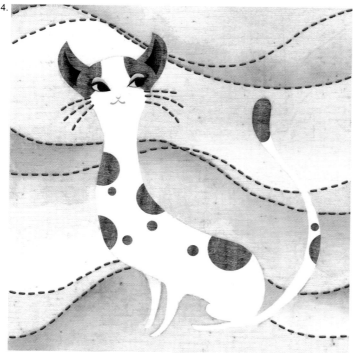

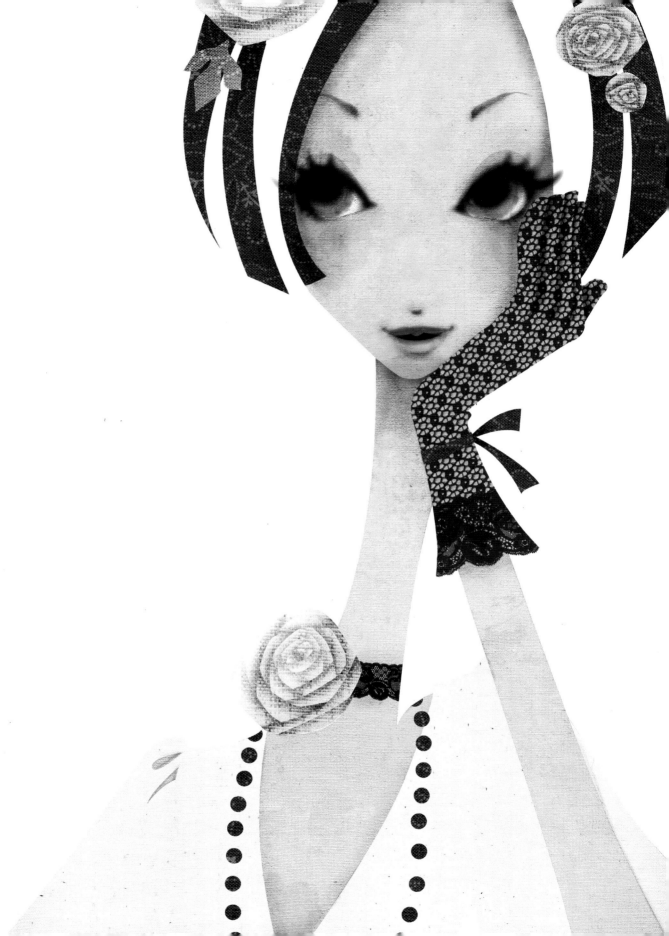

Upon graduation from school, Ms. Izumi was a graphic designer for 10 years before she decided to become an illustrator. Ms. Izumi says, "I draw fun, funny, and happy illustrations with garish colors and unique sensibilities. It is always my goal for my illustrations to make people happy and to surprise them at the same time." People who visit her exhibitions certainly find surprise and joy with her creations, like fun cut-out signs to put your face in and take a photo as if you were at an amusement park, or a "paid adult corner," or a "Fundoshi Fashion Show" (Fundoshi is Japanese traditional underwear similar to a loincloth), or drawing directly on automobiles, and more. She is a master at utilizing these and other great devices to consistently delight her guests. "I like to boldly defy boundaries and cherish traditions at the same time."

Awards & Shows: Honors at The 1st KFS Picture Book's Drawing Contest (2003); Honors at The 10th International Public Art Future Exhibition (2005), and many more... Exhibitions: Solo Exhibition "100 People in Tokyo, Nagoya and Osaka" (2004-2006); "The Place of the Angel" at the Bartok Gallery in Tokyo (2005); "GOMENNASUTTENTEN (I am sorry)" at Bartok Gallery in Tokyo (2005); "GOMENNASUTTENTEN (I am sorry)" at Bartok Gallery in Tokyo (2006); "Picture Book" at Bartok Gallery in Tokyo (2007); "A World for 18 & Older" at 10w Gallery in Osaka (2007); Solo Exhibition "Substance of the Era" at Tea Lounge Creztori in Tokyo (2007); "GOMENNASUTTENTEN (I am sorrrrrry)" at Bartok Tomorrow in Tokyo (2008); "Drawing Fukagawa and Fundoshiya" at Fukagawa IPPUKU in Tokyo, and many more...

Clients: Cisco Systems, Inc., NEC Corporation, Toppan Printing Co., NHK Educational Channel, The Asahi Shimbun Newspaper, Recruit, Unified Super-Commerce (Taiwan), many other publishers, and many more...

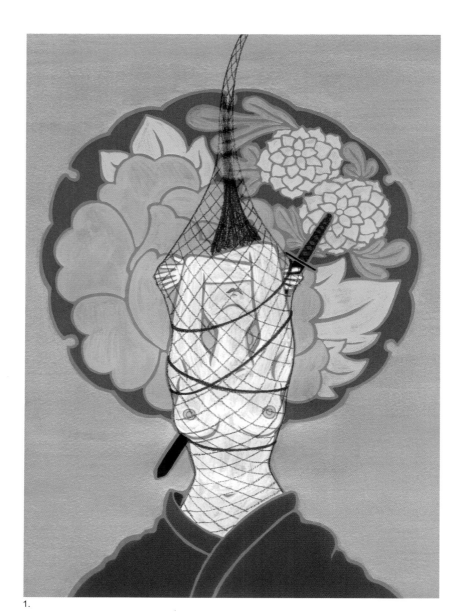

1.

Sakuan **Izumi**

Sakuan Izumi
E-mail: sakuan_izumi@ARTas1.com **URL:** www.ARTas1.com/info/sakuan_izumi
Tools: acrylic gouache, color pencil, pen **Titles:** 1. Kunoichi (A Female Ninja) 2. Cracking A Watermelon (P77)
3. A Moon Thief 4. A Flower Stealer 5. "Fundoshi" Model - Front 6. "Fundoshi" Model - Back
7. A Superb View (P79)

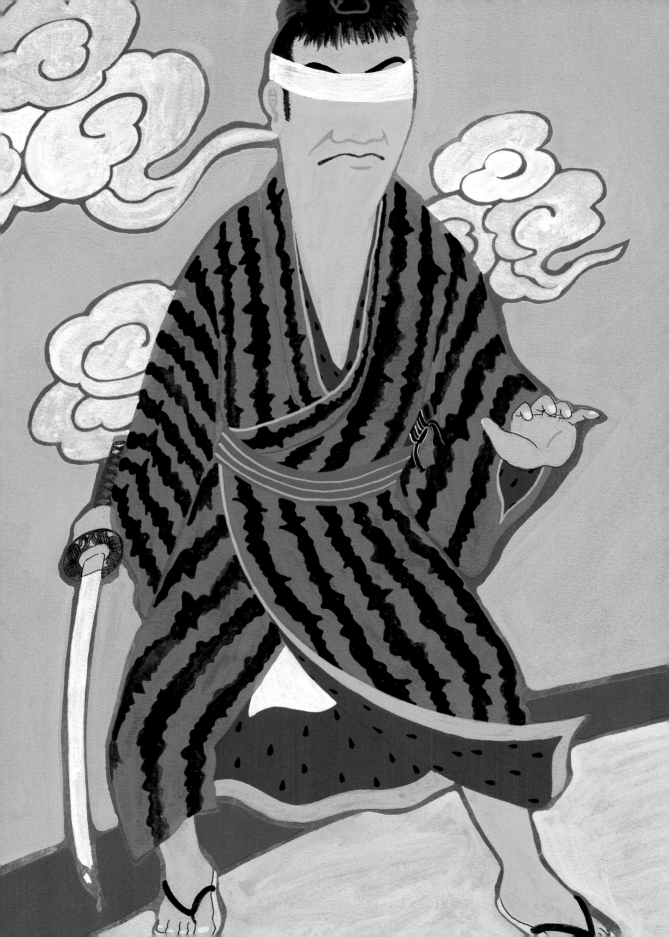

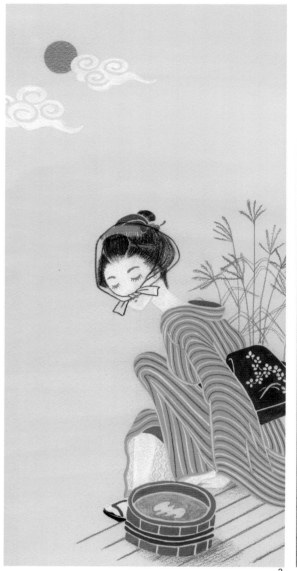

3.

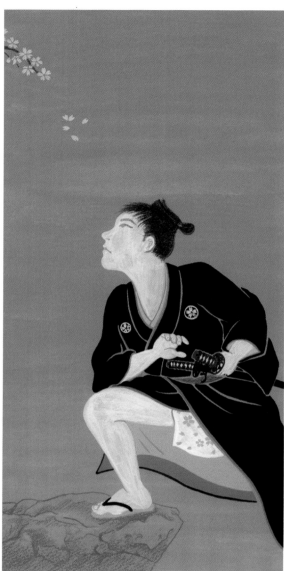

4.

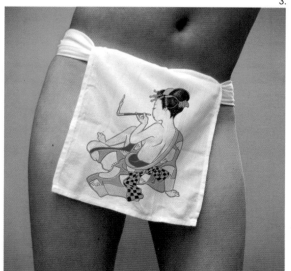

5.

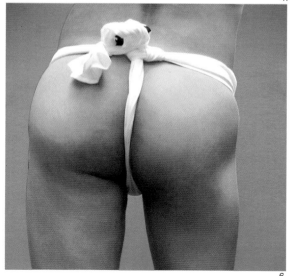

6.

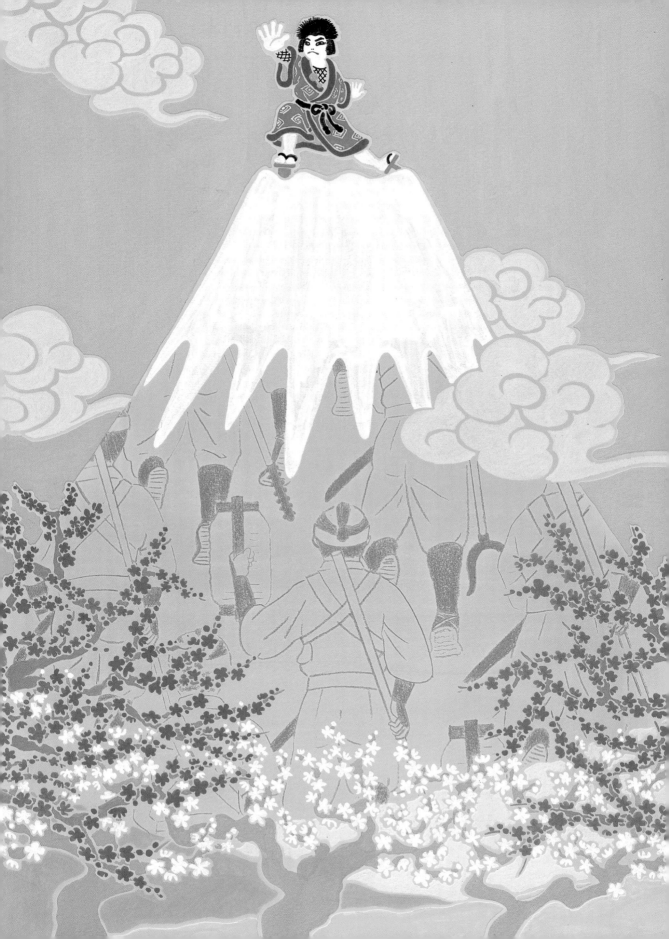

Mr. ESHIMASA was born in Nagoya and began his career as a lowbrow air brush artist. He now lives in Yokohama. Over the years and through inspiration from *Ukiyo-e, Rimpa,* and Lowbrow Art, he has created works that fuse Western and Japanese themes combining *"Wa," "Black & Gray,"* and *"Oppai/Devil."*

CLIENTS: *Drawings and costume design for All Japan Pro Wrestling's "Mamoru Takashi Muto" game, LLPW (Ladies Legend Pro Wrestling)'s "Shinobu Kandori" game, and LLPW's "Takako Inoue" game; Collectible stage costume design drawings for impersonation celebrity Tony Hirota; Image Visuals for "INVADER" custom car; Countless original prints for tattoos; and many more...*

AWARDS & SHOWS: *Exhibition at San Diego Comic-Convention (2002); Exhibition at Thailand Animation and Multimedia 2004 in Singapore (2003); Exhibition at Air Brush Show 2004 in Milano, Italy (2004); Exhibition at Batik Art Group Special XXX Anniversary Batik in Barcelona (2004); Cow Parade Tokyo Invitational (2006); Live paint performance with lowbrow artist "The PIZZ" at "The PIZZ attacks TOKYO" (2007); Art Direction and costume design in short movie Kage.*

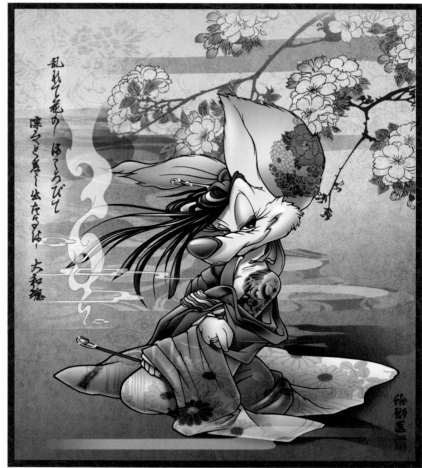

1.

ESHIMASA

ESHIMASA
E-mail: eshimasa@ARTas1.com URL: www.ARTas1.com/info/eshimasa
Tools: airbrush, Adobe Illustrator, Adobe Photoshop **Titles:** 1. Oiran (a high-ranking prostitute) Mouse
2. Gakyoryu (Painting A Deranged Dragon) (P81) 3. Ane-san (A Senior Geisha)
4. Byakko (White Tiger) 5. Flower and WA Series All images pages 80-83 © 2008 by ESHIMASA

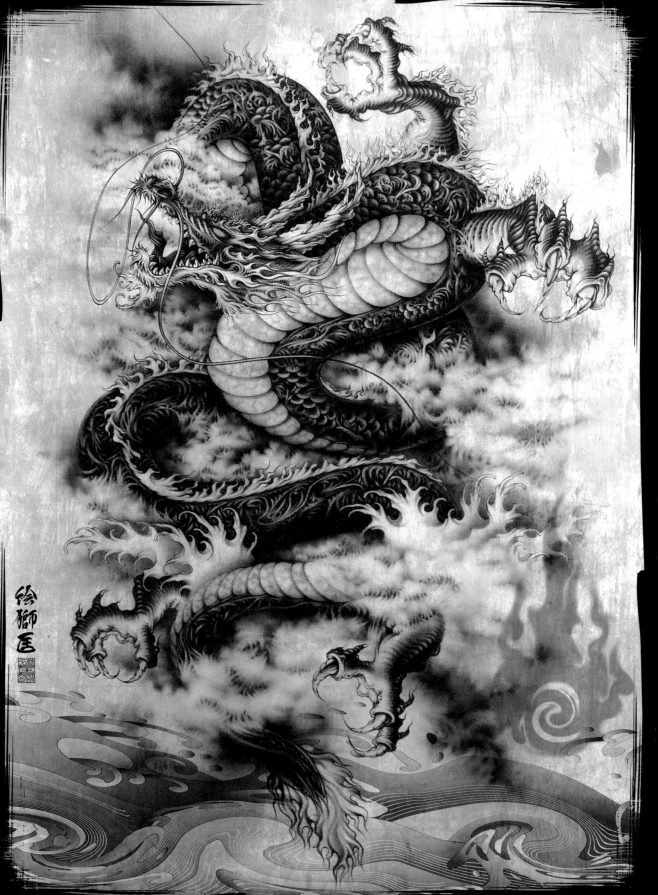

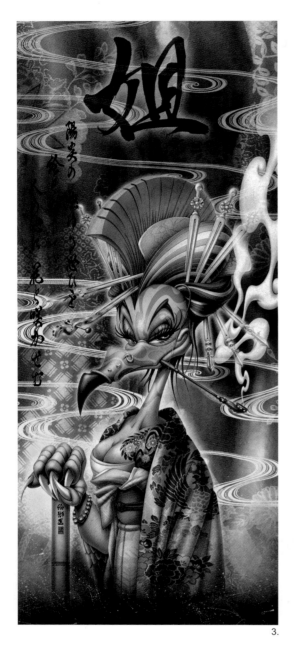

3.

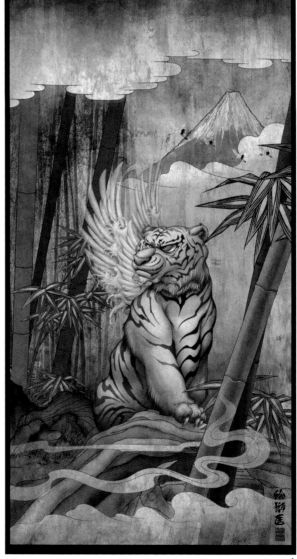

4.

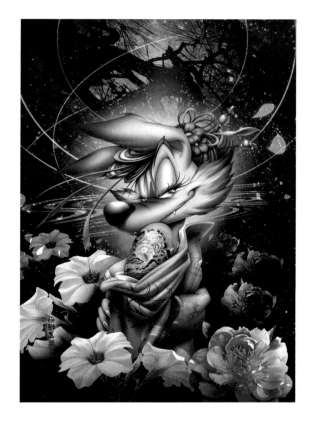

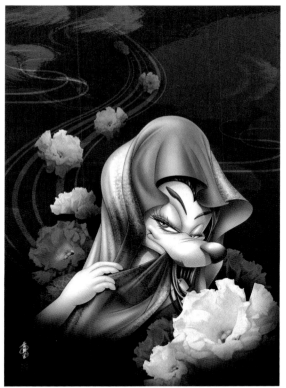

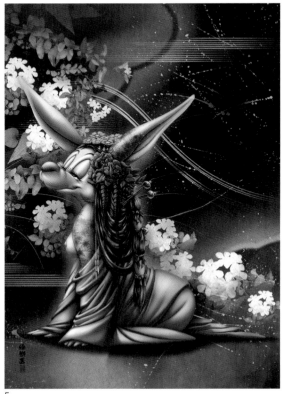

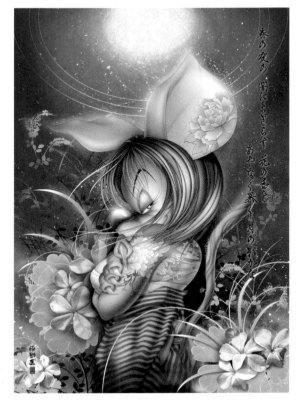

5.

Three years ago, Mr. Losef was simply doodling while killing time, but then was overwhelmed with compliments over his creation. As the praise poured in, his life was awakened to the art world. As a self-taught artist, Losef creates his unique approach by learning from all things he sees and reflecting deeply into himself. His works represent the indisputable "truths" in his life.

"I want to create art that changes shape based on the sensibilities of the viewer. Moreover, I want the experience of encountering my creations to shock the viewers, and help them, one-by-one, to have deep revelations about their own lives. I believe that is the power of art."

1.

Losef

Losef
E-mail: losef@ARTas1.com URL: www.ARTas1.com/info/losef
Tools: Adobe Photoshop, Adobe Illustrator Titles: 1. butterfly 2. tree of temptation (P85) 3. opening (P86)
4. core (P87) All images pages 84-87 © 2008 by Losef

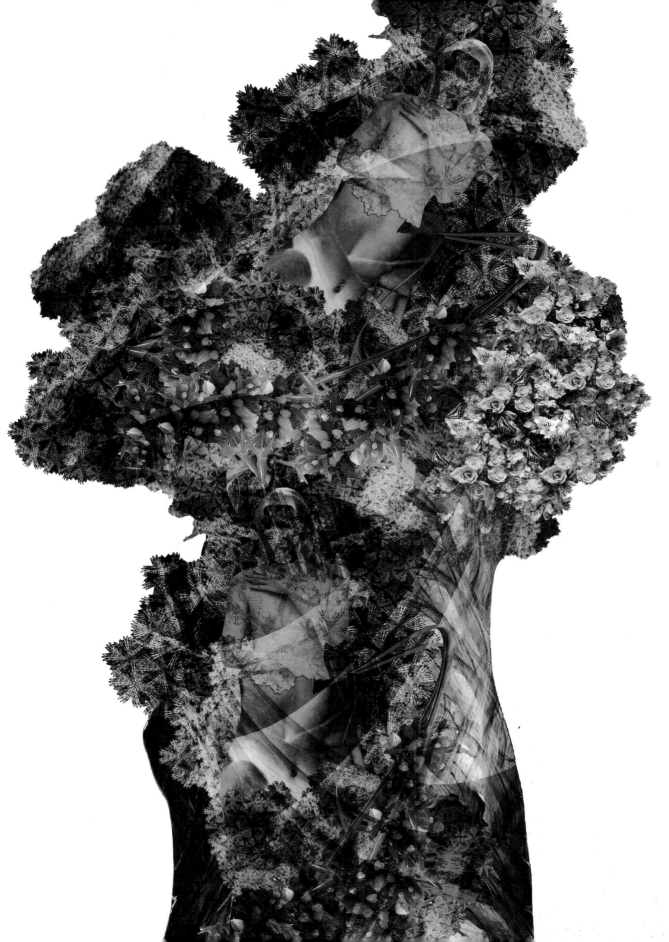

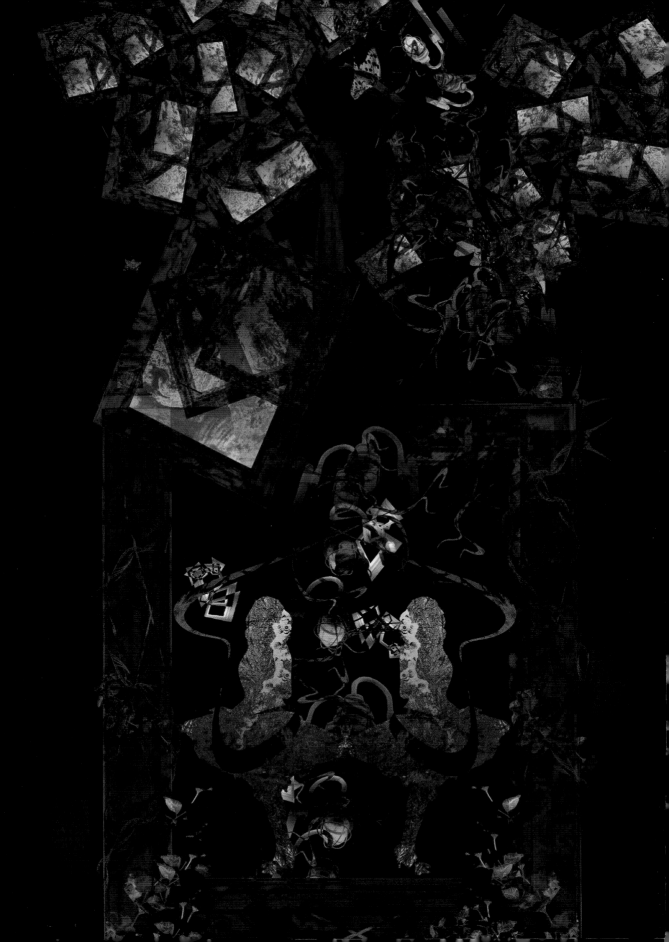

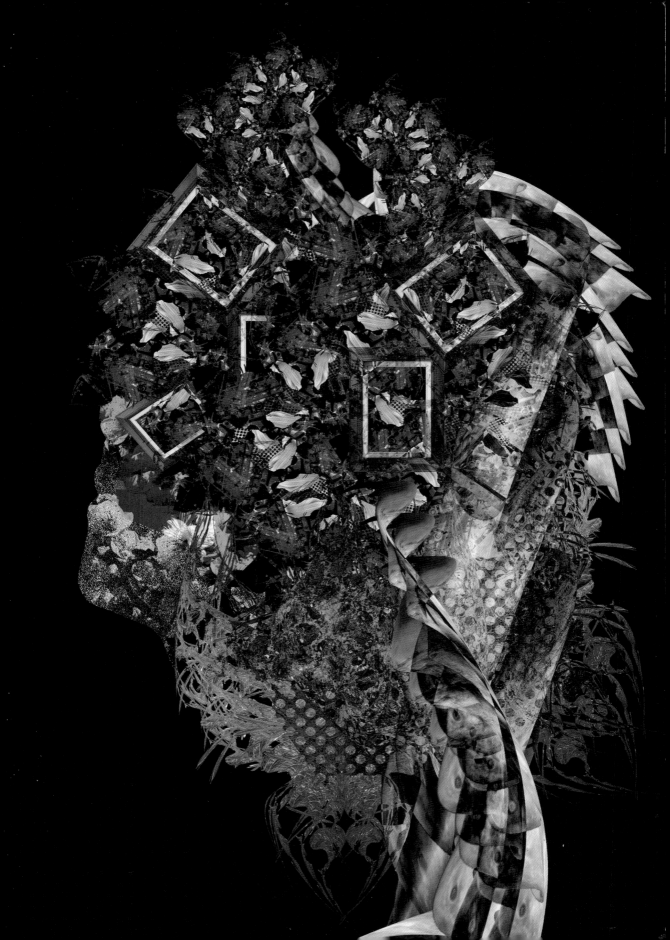

Ms. Takenaka's unique illustrations have a strong sense of spirituality. Her creations contain magical realism with intricate storylines. Having worked with a wide variety of clientele ranging from authors to publishers and musicians to music labels, she understands the necessity to fully comprehend clients' needs and she consistently exceeds her clients' illustration expectations. One of her specialties is collaborating with progressive, rock, jazz, and classical musicians and music labels on designs.

CLIENTS: Illustration and event logo for "Vintage Rock in HIROSHIMA"; Music Industry, Publishing Industry, Advertising Industry, and many more...

AWARDS & SHOWS: "Best" Award at The 3rd International Illustration Competition (2002); Rotring/Stabilo Competition Award ('95); Award of Excellence at Anabuki College Group Summer Greeting Letter Design Competition ('94)

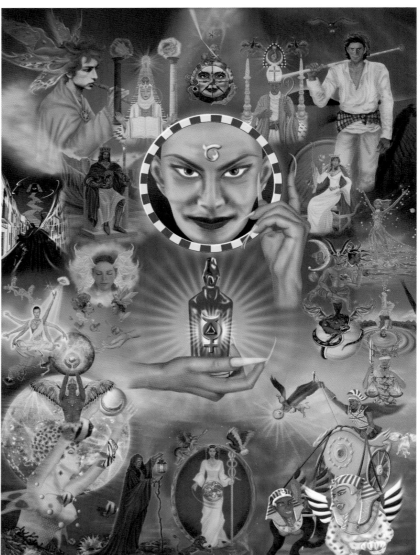

1.

Mitsuki
Takenaka

Mitsuki Takenaka
E-mail: mitsuki_takenaka@ARTas1.com **URL:** www.ARTas1.com/info/mitsuki_takenaka
Tools: Adobe Photoshop, liquitex color, acrylic gouache, Stabilo Funcolor, Sakura Conte Pastel
Titles: 1. The Cosmos of Tarot 2. The Dancing Doll 3. The Dancing Doll 4. The Moon 5. The Lovers
6. Wheel of Fortune 7. The Devil 8. Nirvana (P90-91) All images pages 88-91 © 2008 by Mitsuki Takenaka

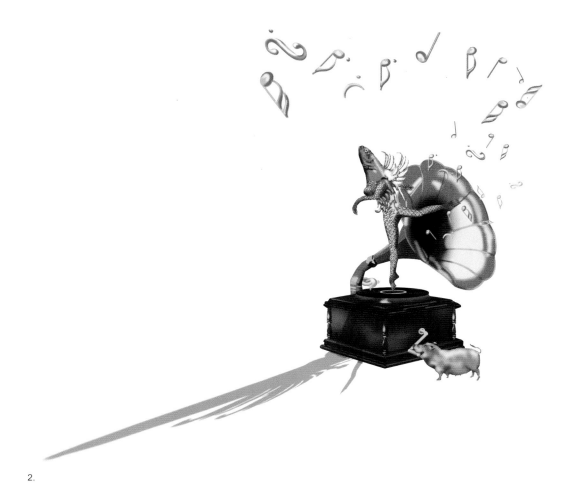

2.

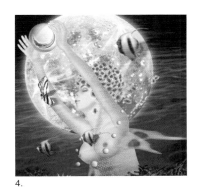

3.

4.

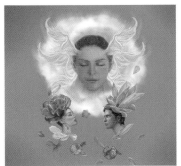

5.

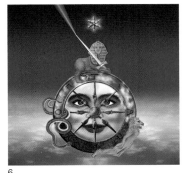

6.

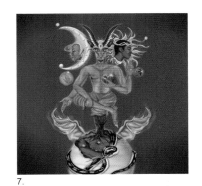

7.

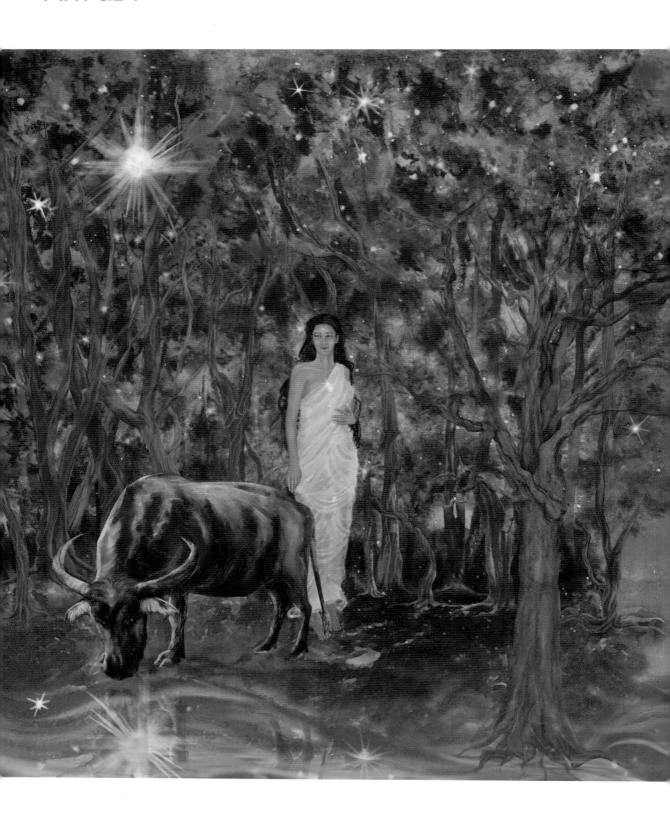

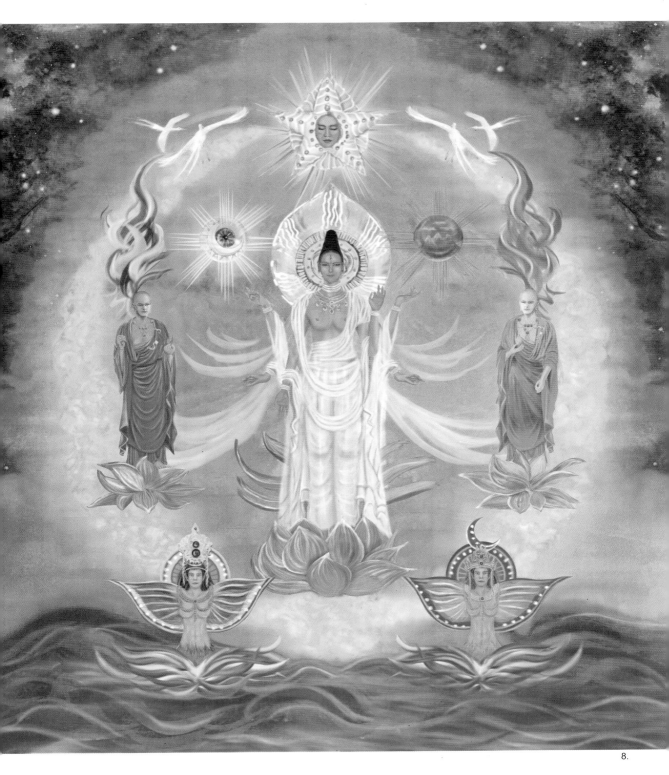

ARTas1®

Mrs. Suni-lovE has spent much of her young life in Japan as a Korean-Japanese girl who loved to dream and draw. In 2000, she began her formal art education at an illustration school. Focusing her efforts on drawing, CG, and flower arrangements, she matured into her current style. In her artwork, Mrs. Suni-lovE transforms invisible energies such as light, love, and positive power, filled with colorful colors, into her own unique "dream of a world." Her illustrations feature a fantasy style that enraptures viewers into feeling the joyful gaiety she experienced in her happy childhood.

"Flowers bloom. Simply by their existence, flowers can calm people's feelings and cheer them up while simultaneously providing us with colorful light, energy, and selfless love. That is how I approach bringing a new drawing into existence."

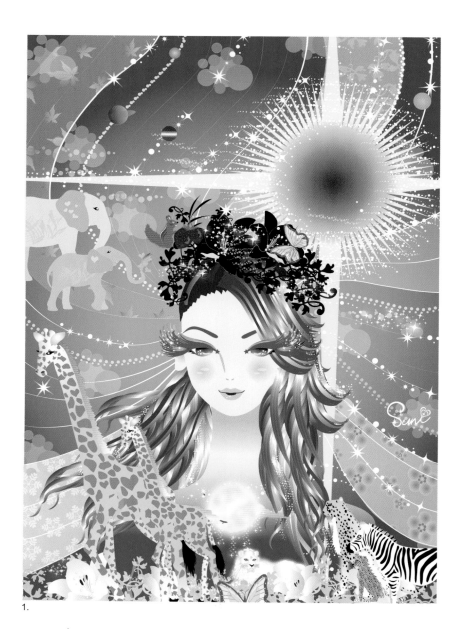

1.

Suni-lovE

Suni-lovE
E-mail: suni-love@ARTas1.com **URL:** www.ARTas1.com/info/suni-love
Tools: Adobe Photoshop, Adobe Illustrator **Titles:** 1. new world 2. birth 3. Divine Magic 4. kira kira
5. Play Time 6. yes All images pages 92-95 © 2008 by Suni-lovE

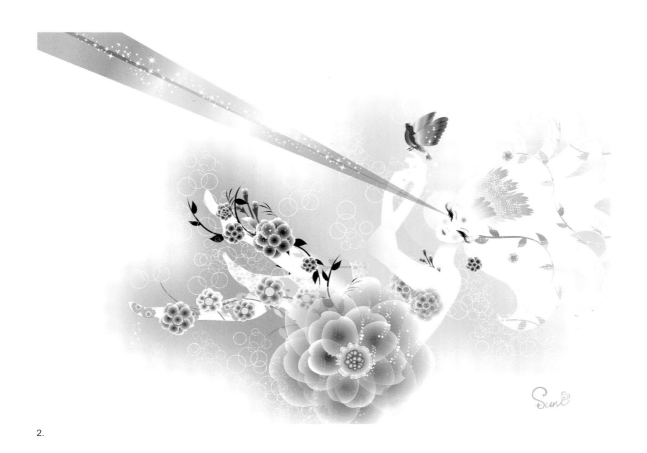

2.

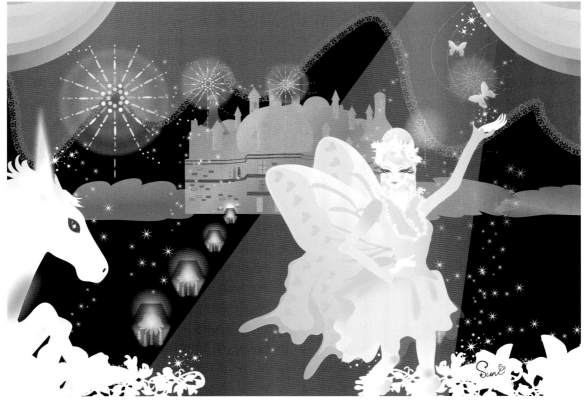

3.

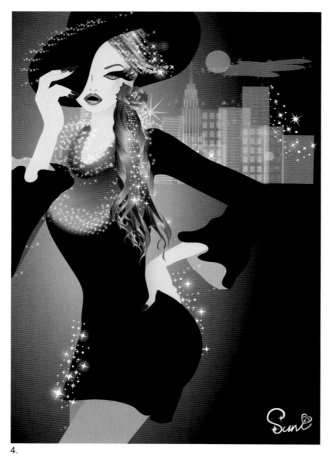

4.

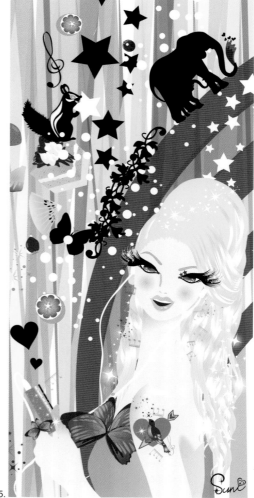

5.

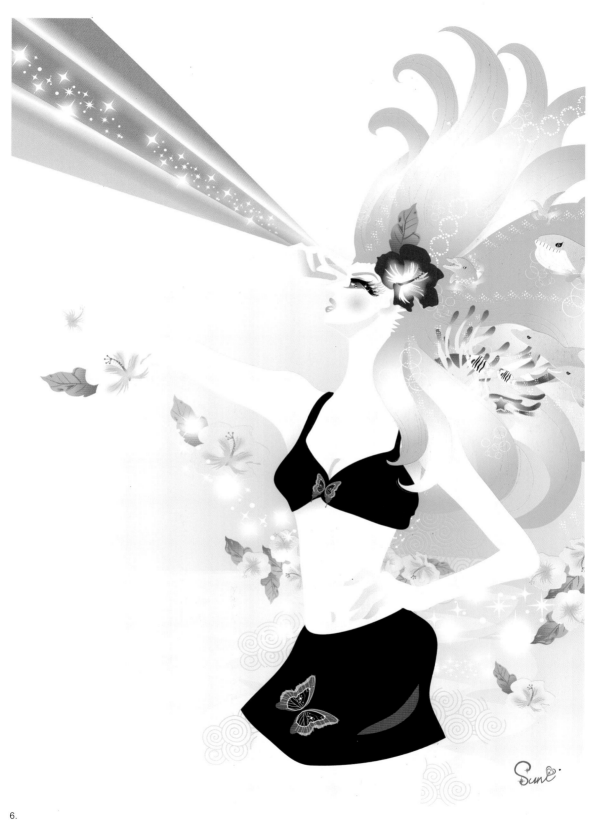

6.

ARTas1®

Japanese Professional Illustrators - Vol. 2

For all English inquiries,
Please contact: **Paul A. Whitney**
E-mail: paulw@ARTas1.com

Headquarters - Los Angeles
970 W. 190th St., Suite 270
Torrance, CA 90502 U.S.A.
Tel: 310.515.7100 Ext. 102
Fax: 310.515.7188

New York Office
214 W. 29th St., Suite 603
New York, NY 10001 U.S.A.
Tel: 888.890.8880
Fax: 212.504.8046